101 Mandalas Coloring Book for Adults
The Art of Meditation

Andrea T. Cross

Copyright © 2019 Andrea T. Cross
All rights reserved.

This coloring book from a Buddhist art has more than 101 beautiful mandalas, animal, flower, and wallpaper designs.

Mandala, which many people define as "art of prayer" This has originated from Tibet that is currently being used to treat emotional conditions for people of all ages. It is a treatment for stress, creates concentration and refreshes the mind for the art students. The interests of the said art are still hidden about the understanding and accept the truth of life for the elderly as well. Due to the artwork that is going to be created in a circle, this is like a fetus in the mother's womb.

Nowadays, it is used as a treatment for the emotional state in people of all ages. In the treatment of the adult with the science "Mandala" First, you will get the subject of "prayer" because while drawing or using colored paint in a circle. Your mind will not be distracted, thus making you feel calmer. More importantly, it also causes the adult to have a "stillness" state. For the adult who is interested in creating relaxation with "Mandala" If you feel that you are weak, chop, and then pick up immediately. This is to calm the mind. Simply said that can be done at all times. Or picking to do often is even better.

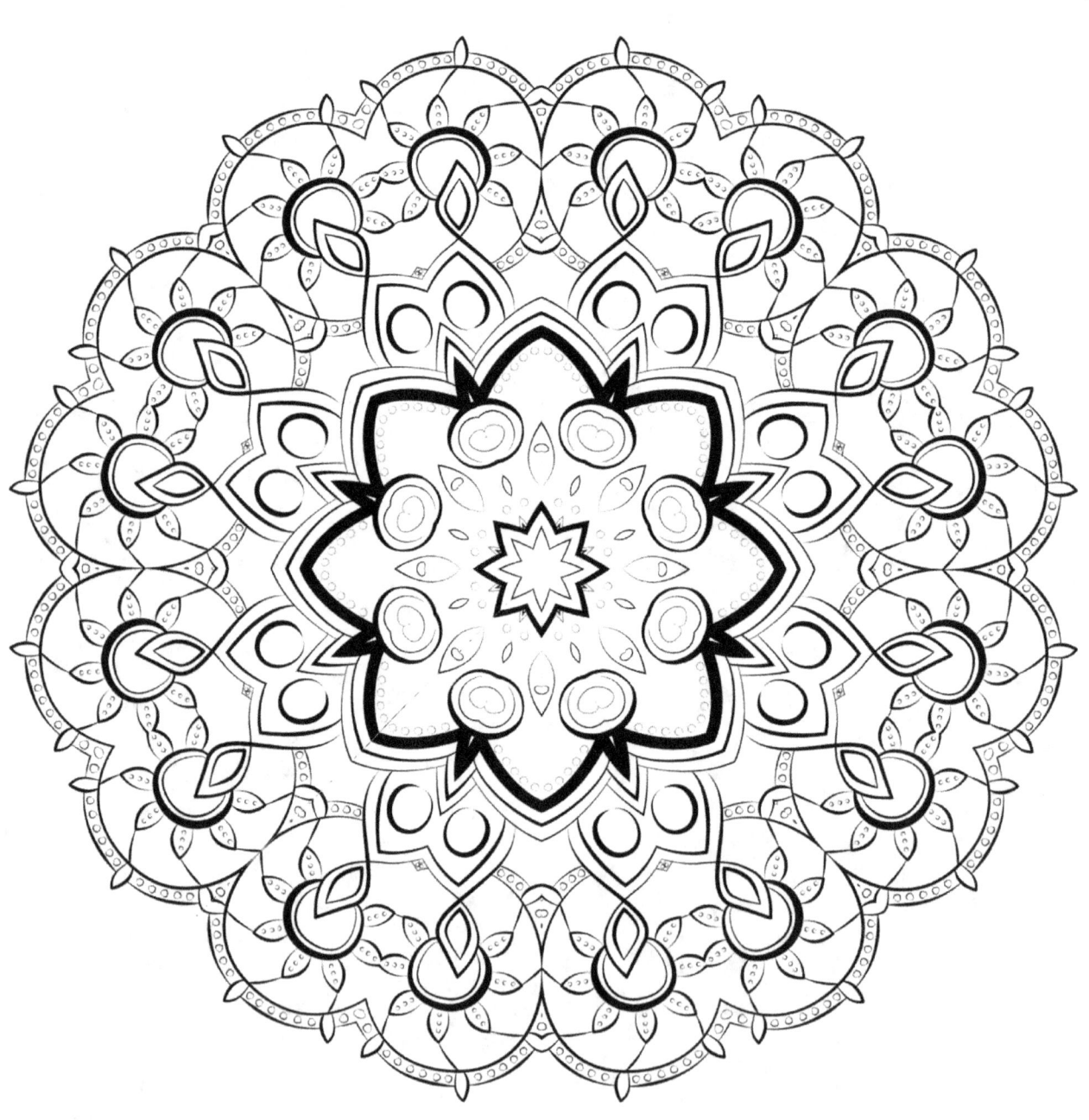

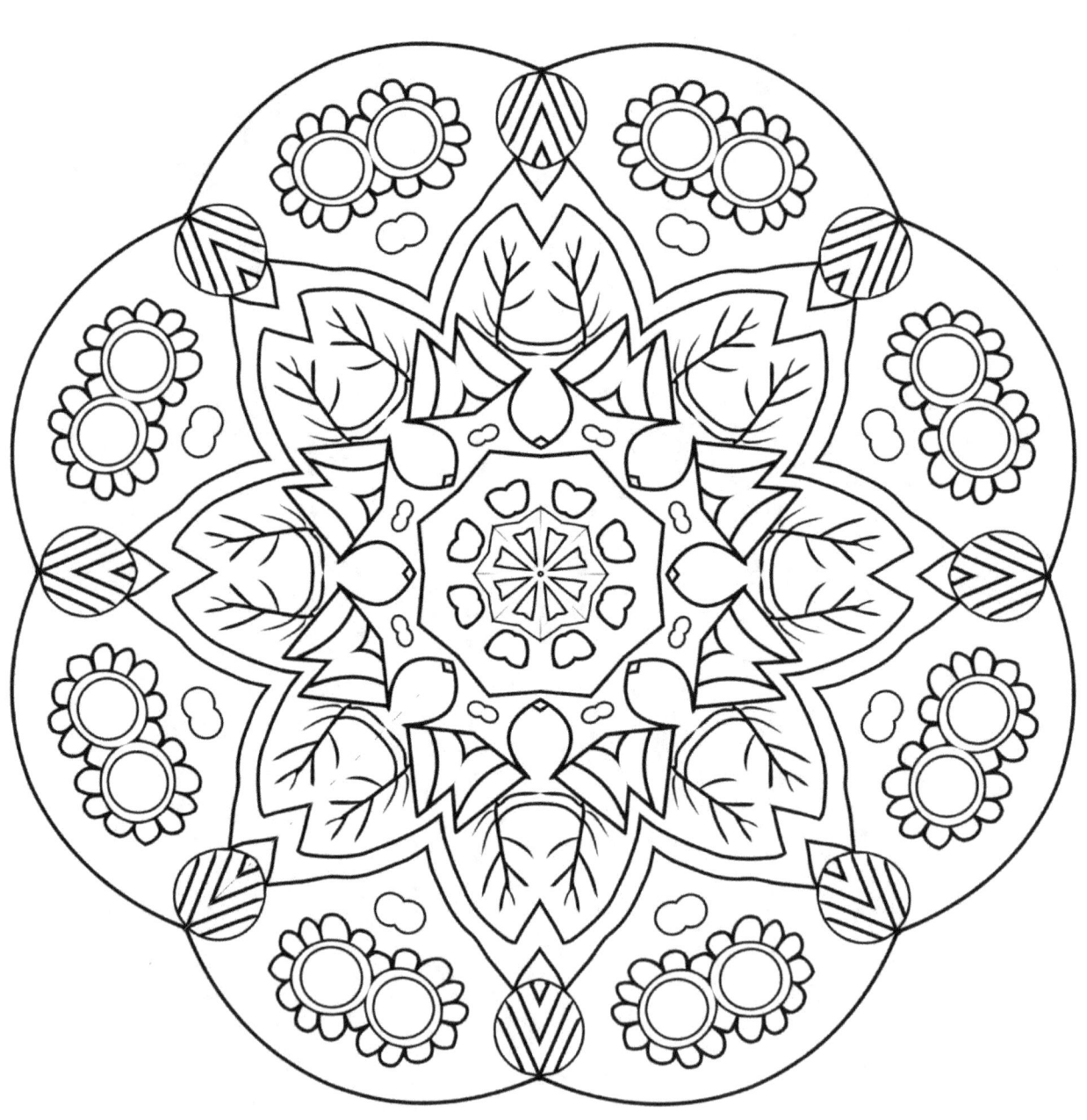

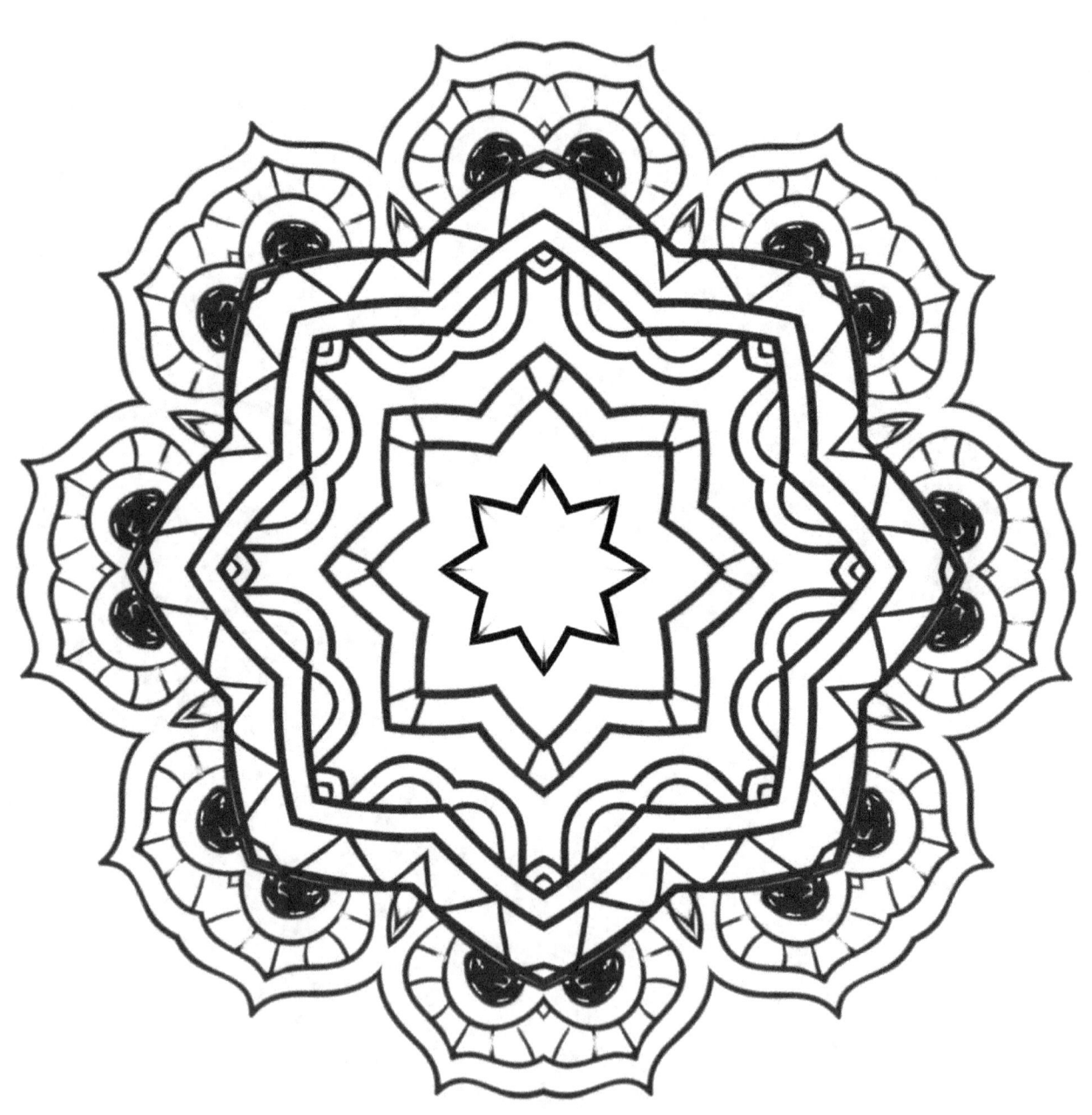

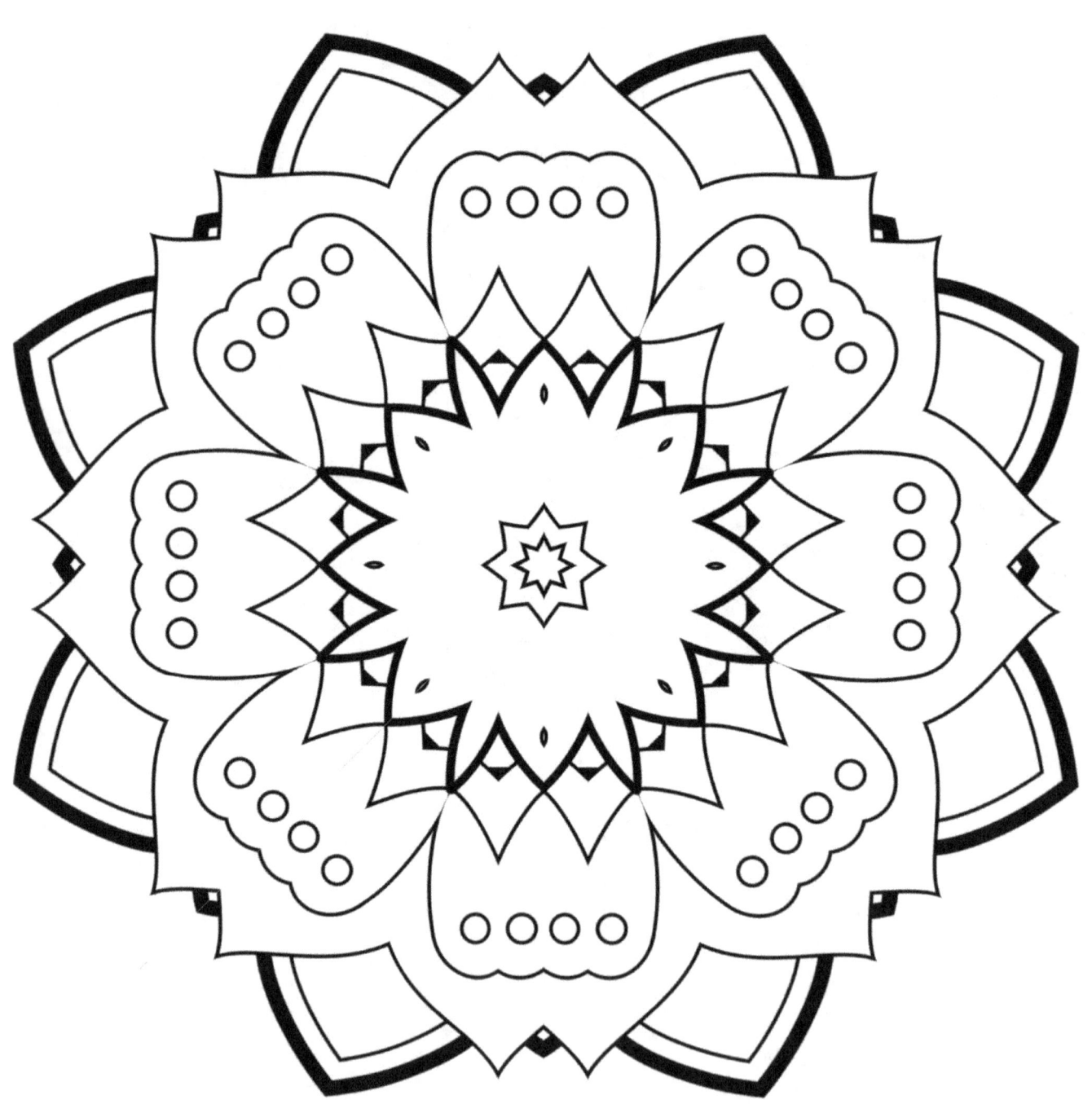

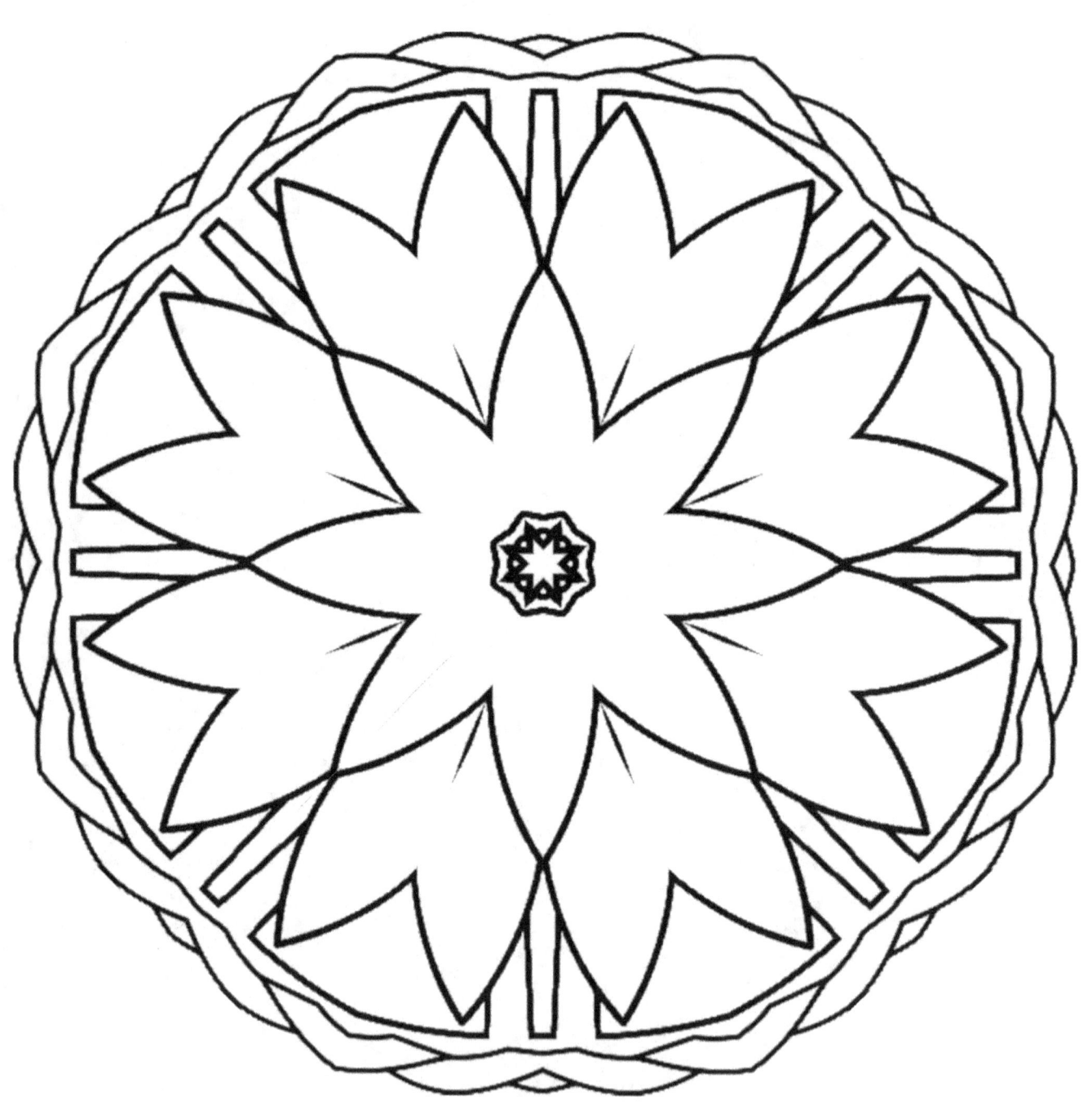

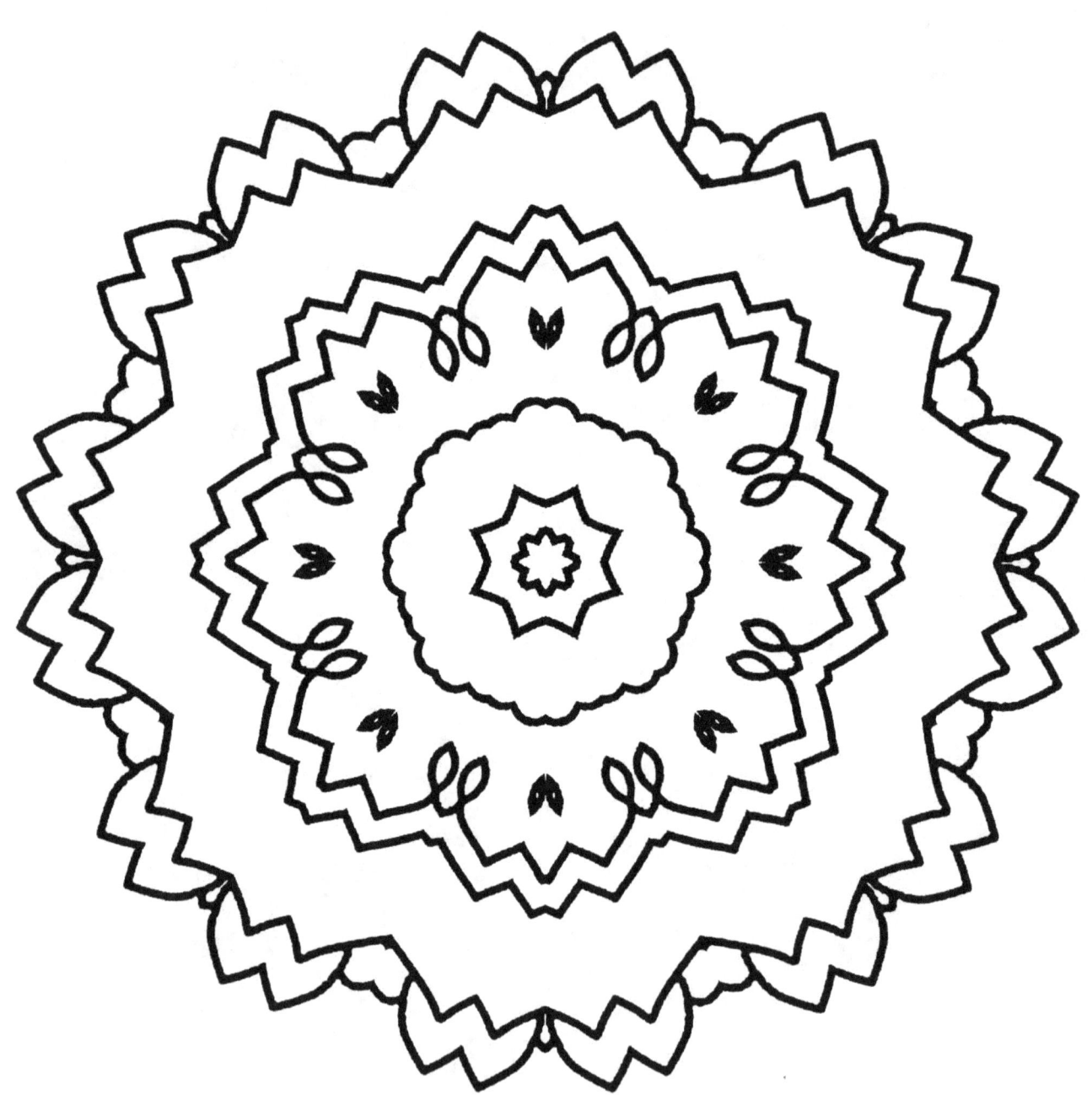

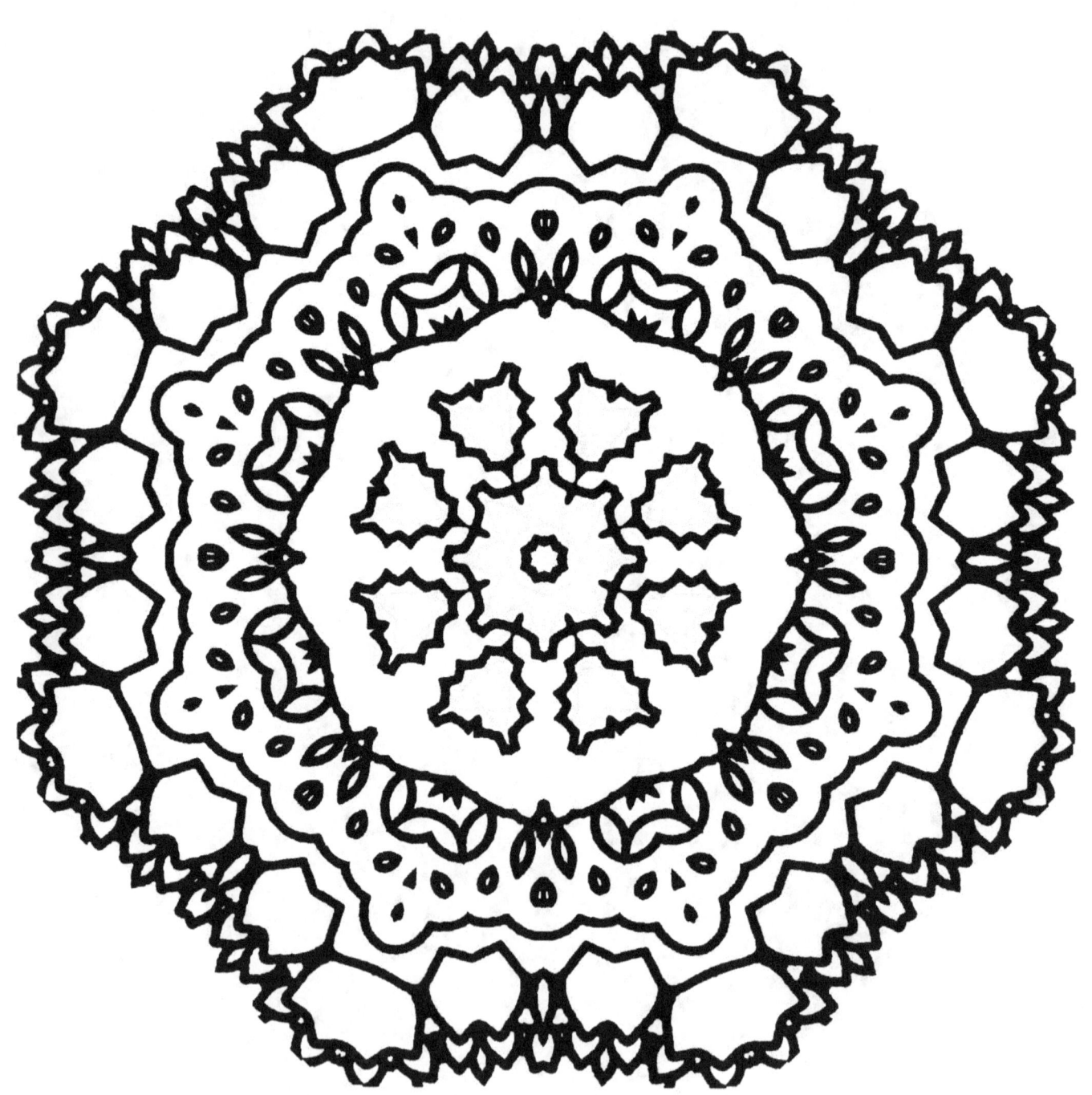

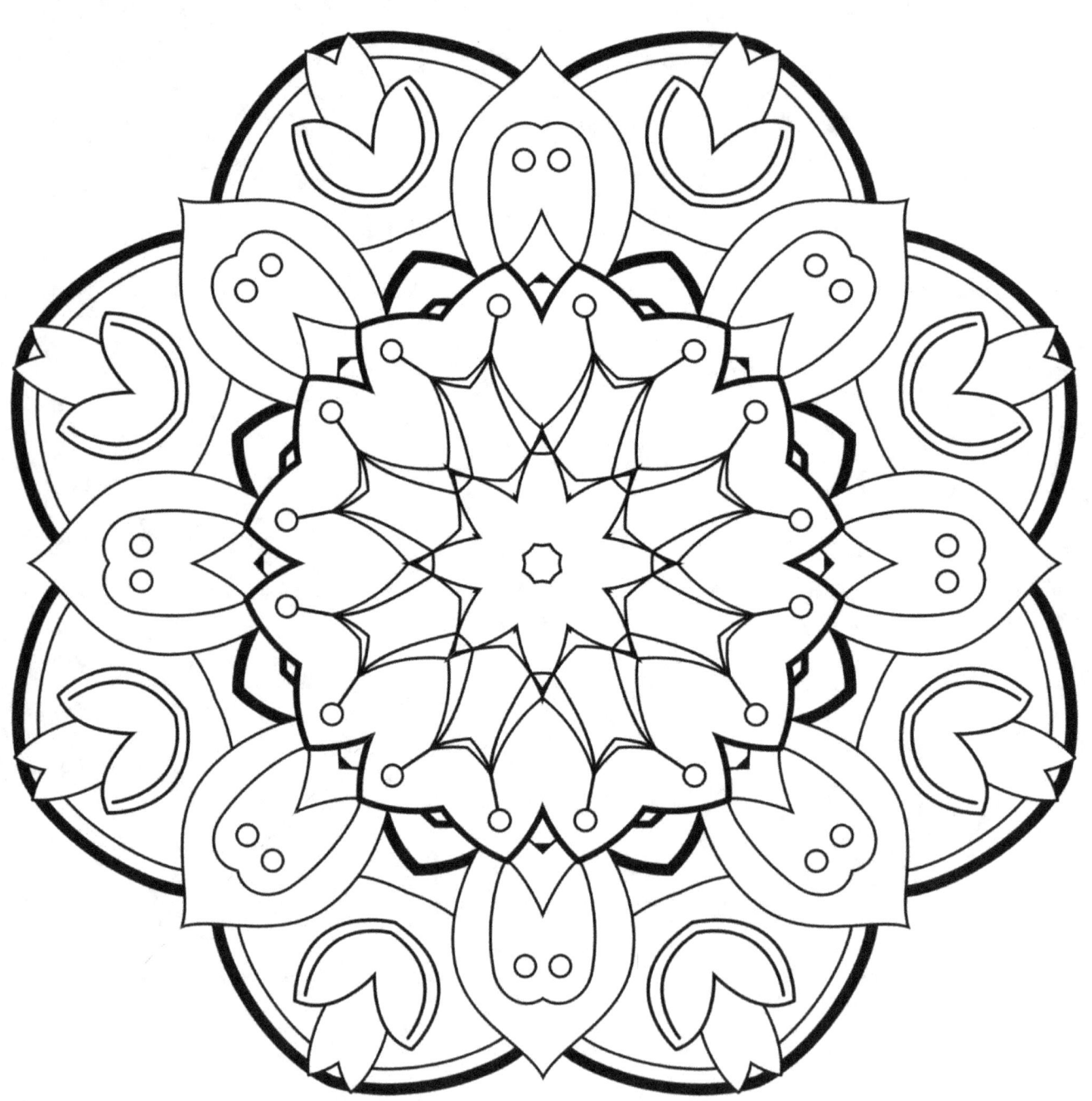

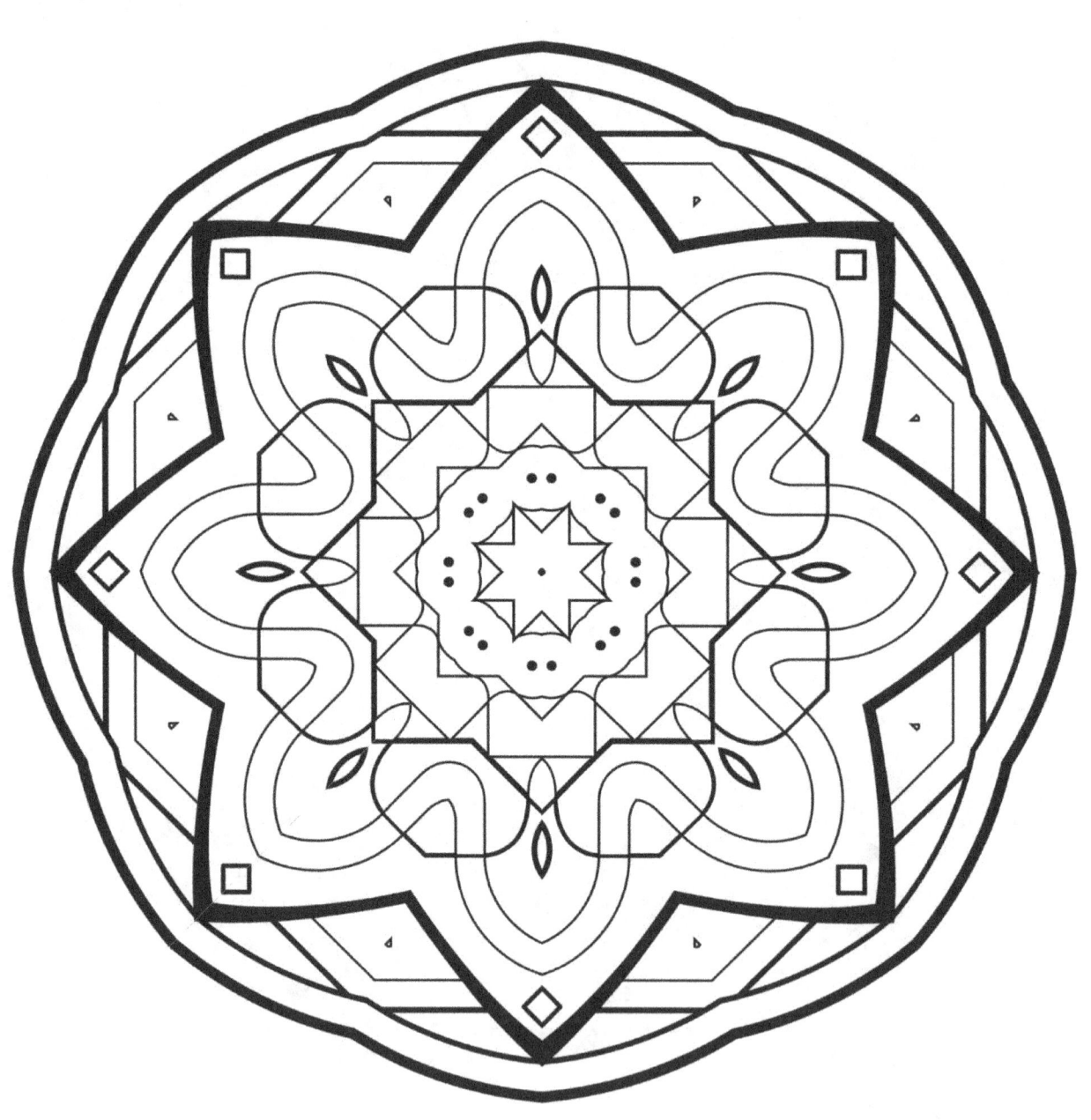

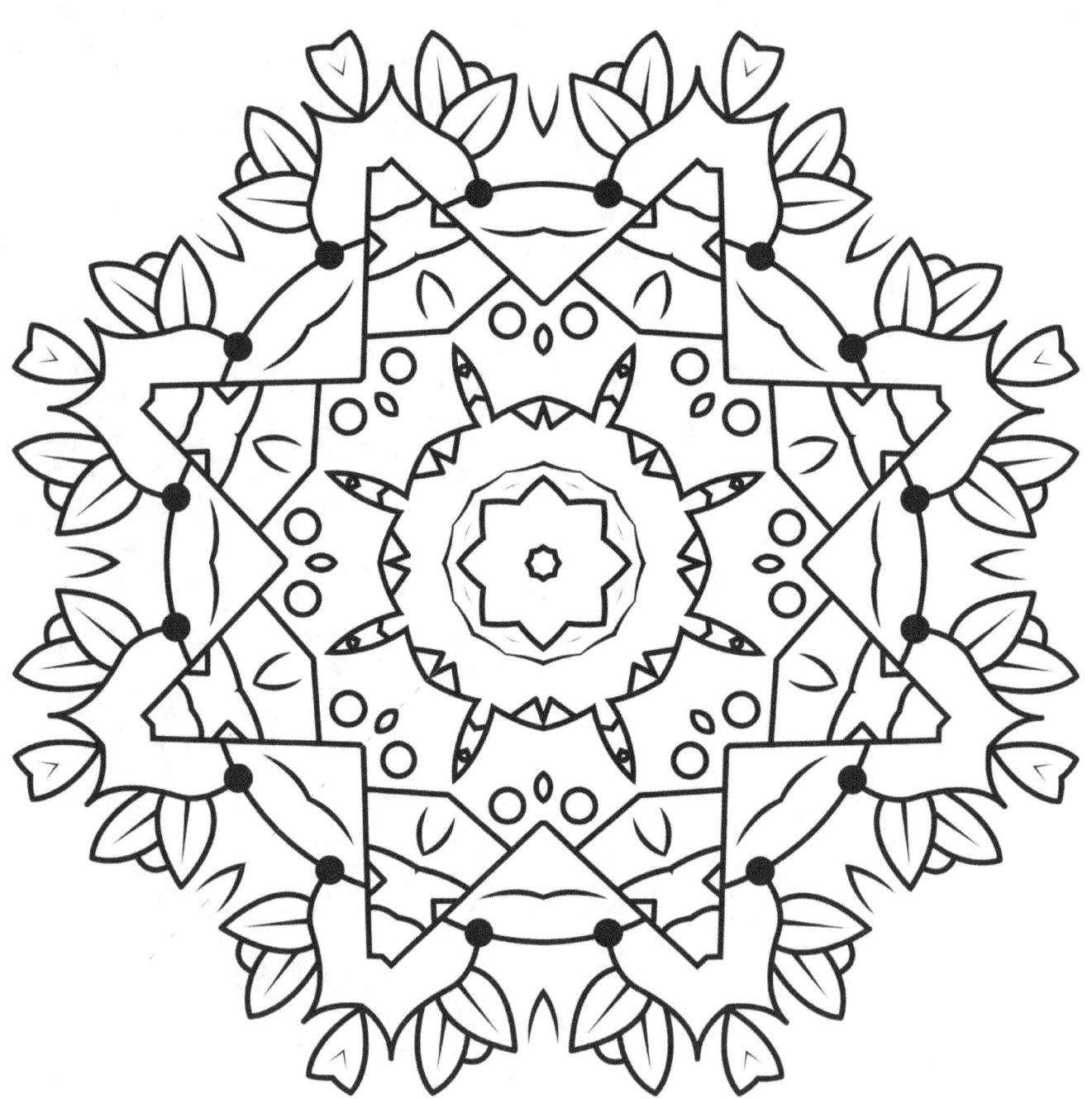

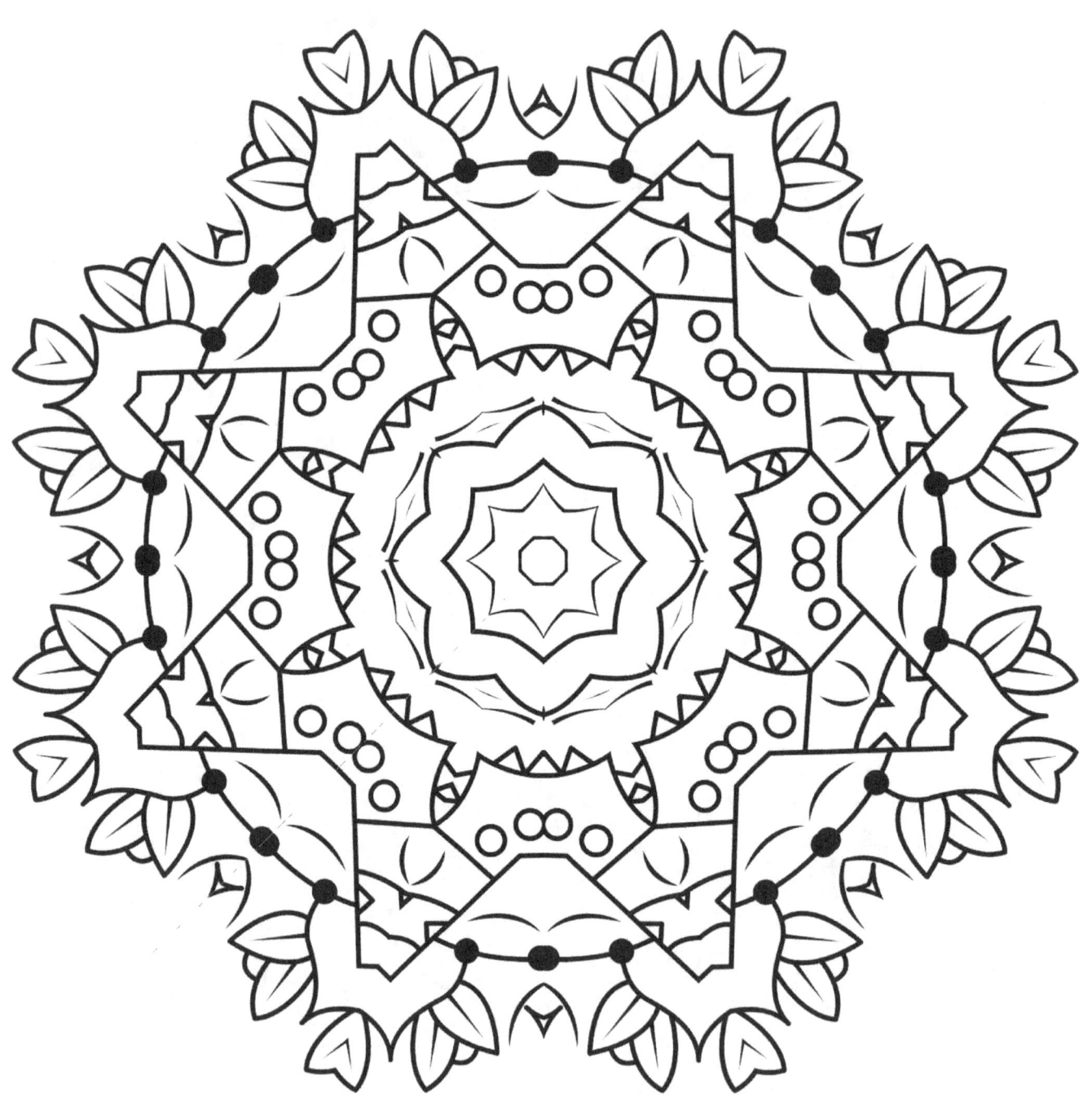

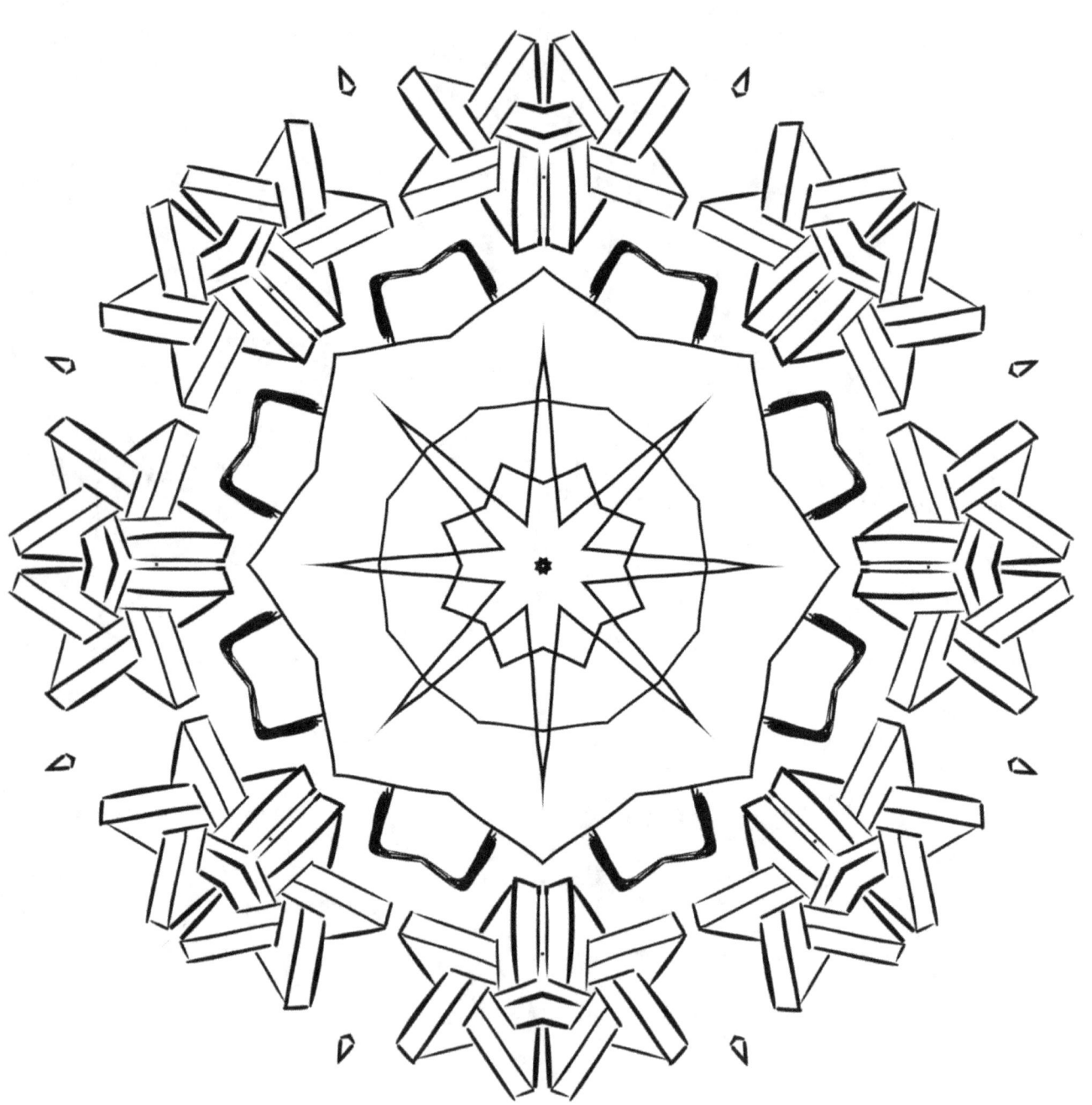

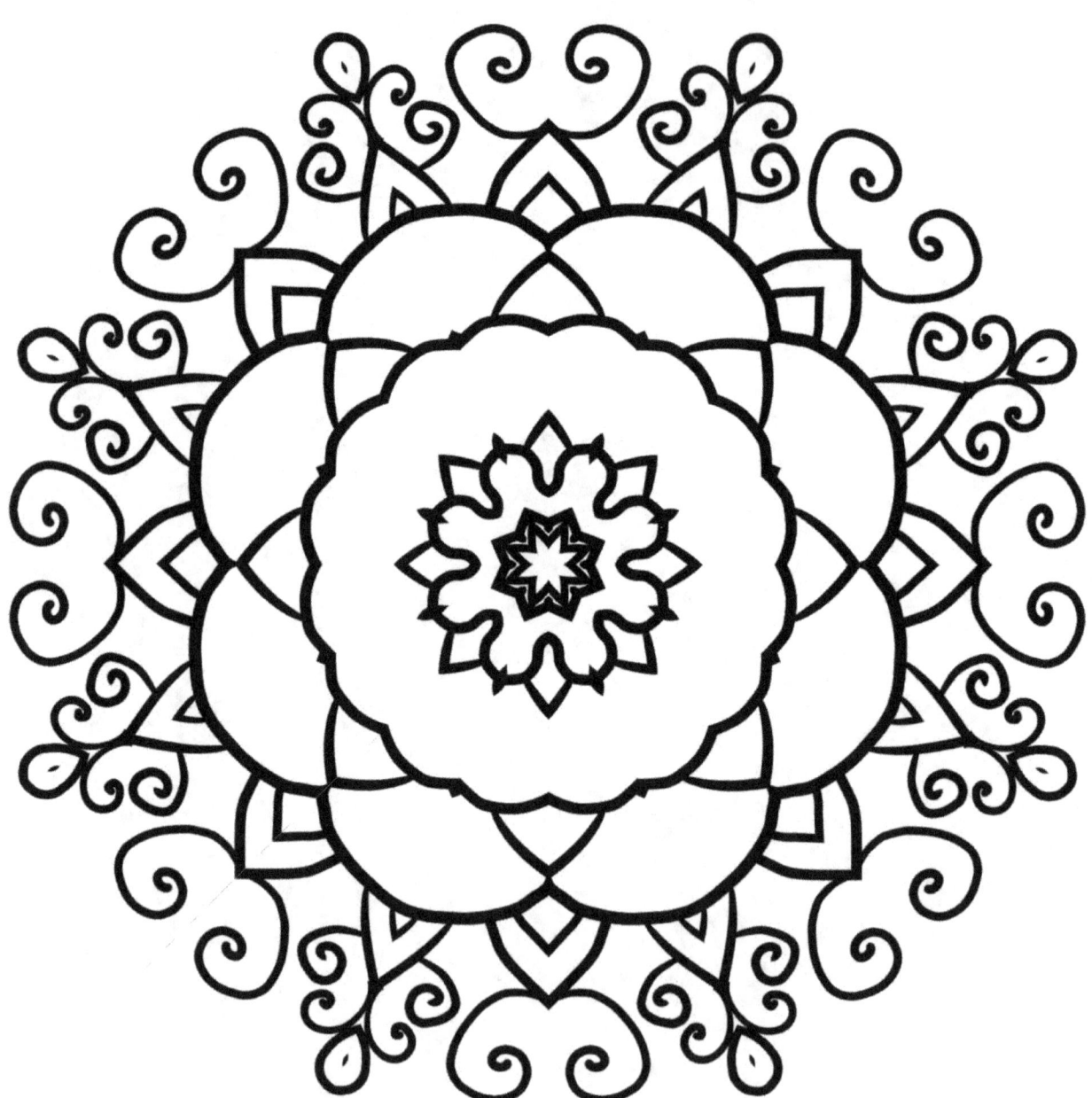

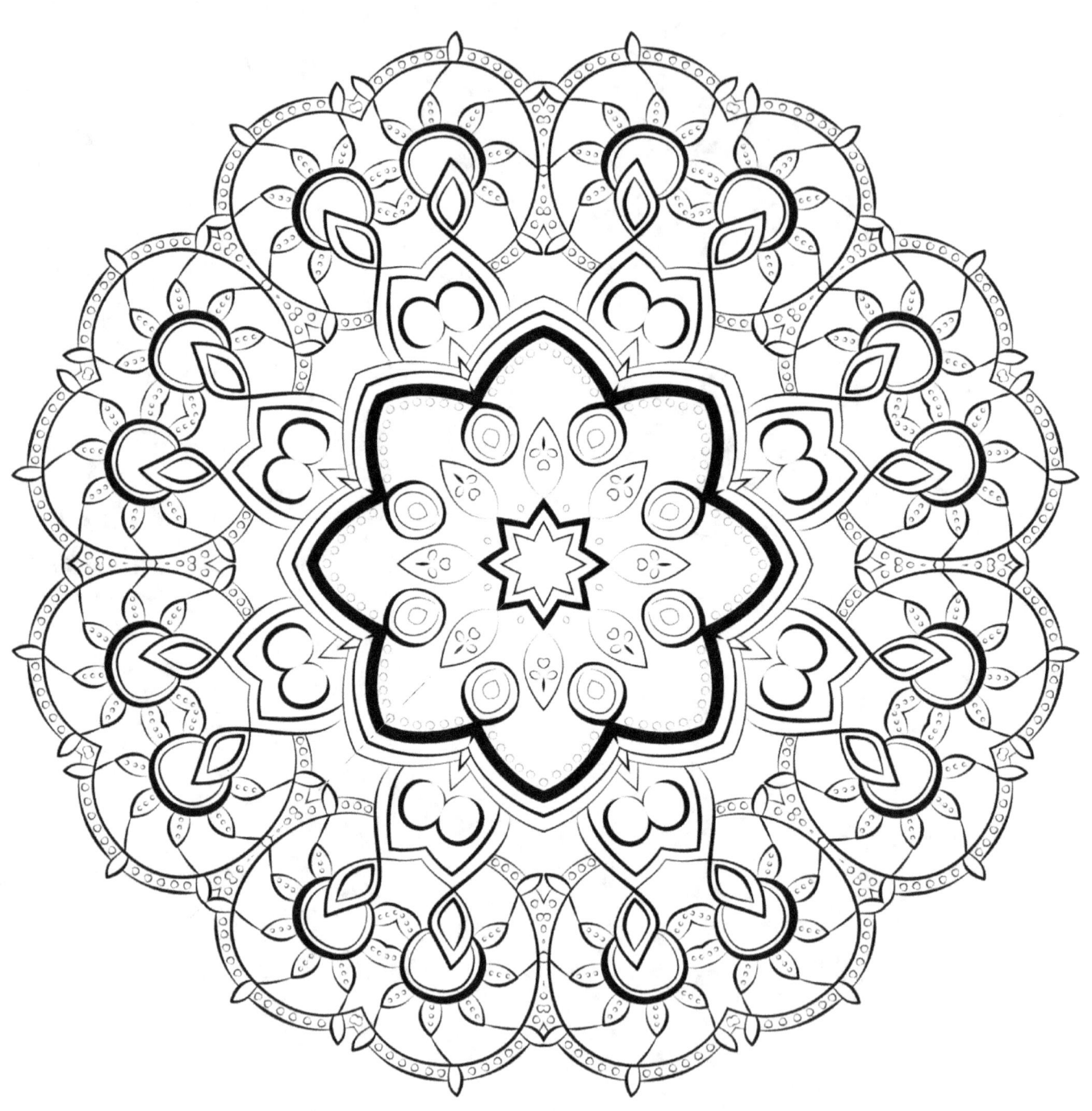

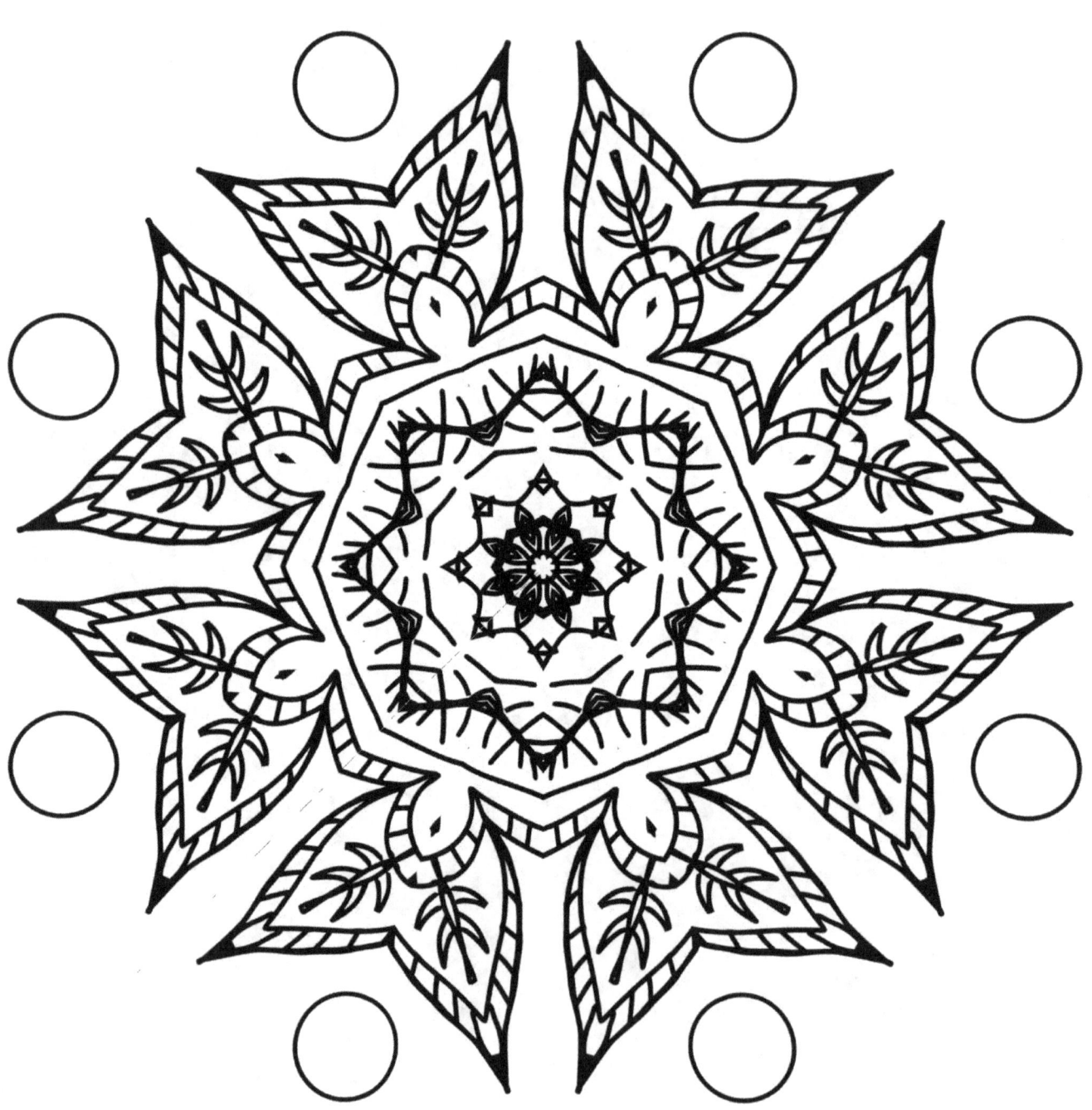

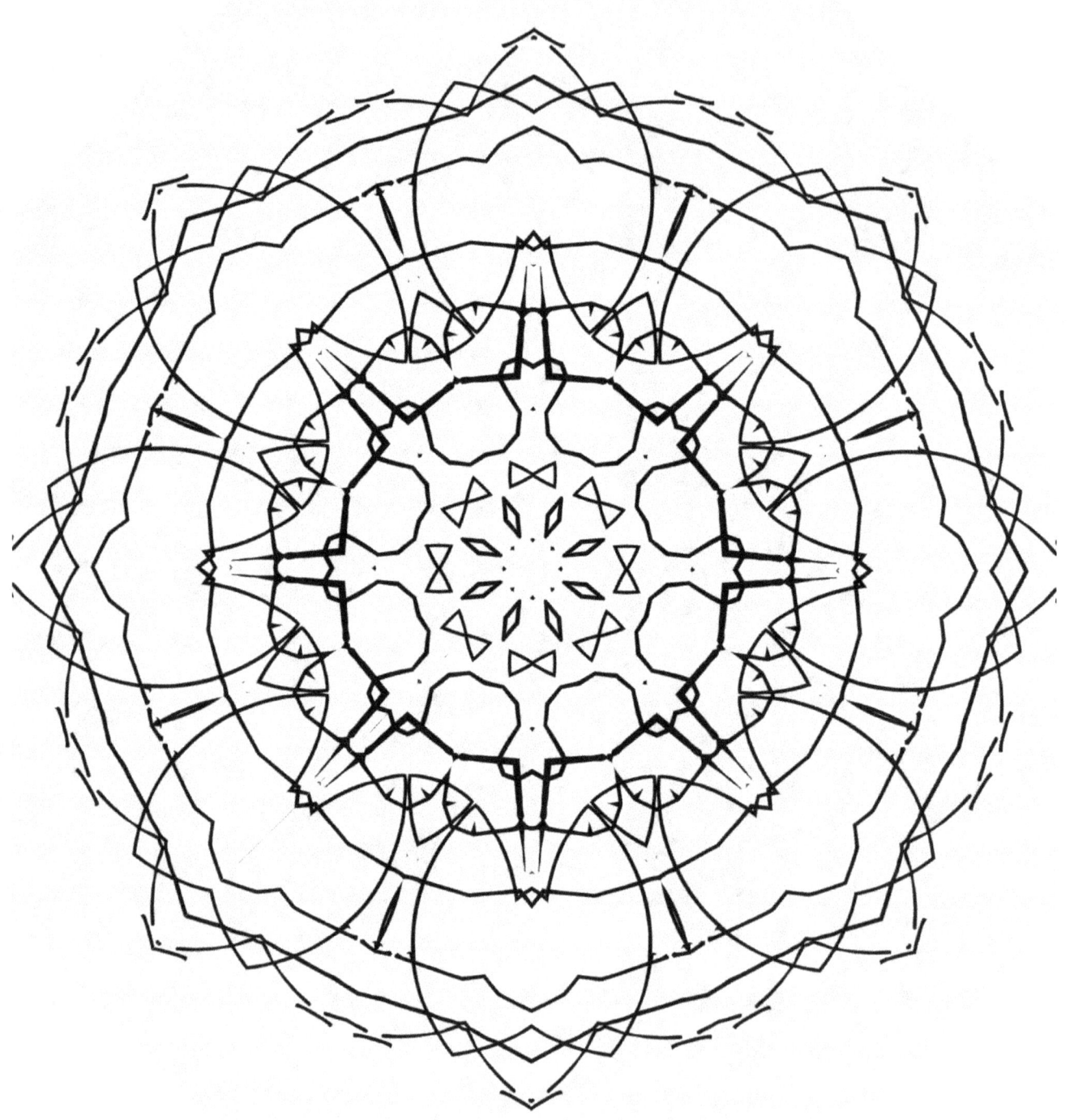

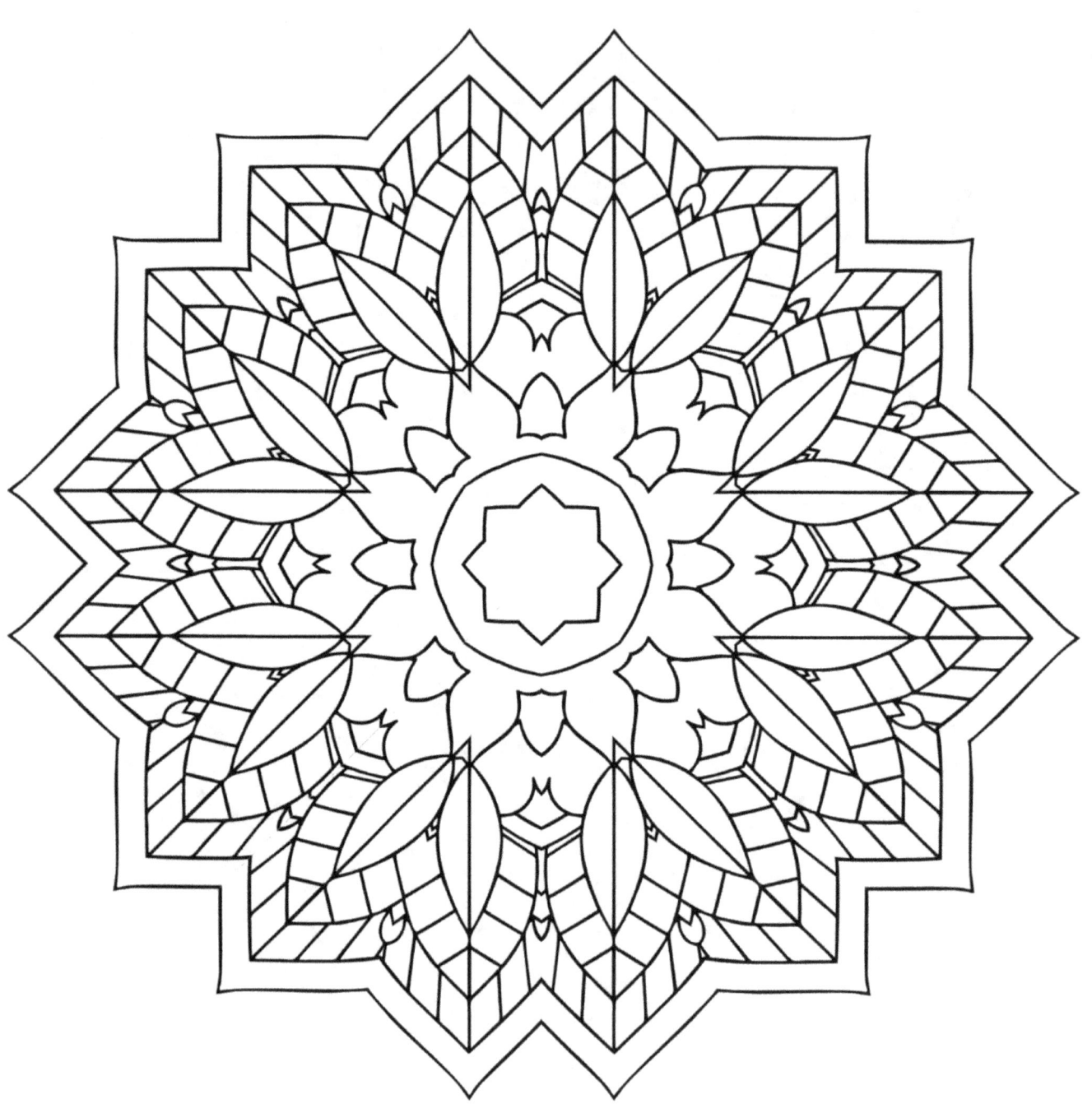

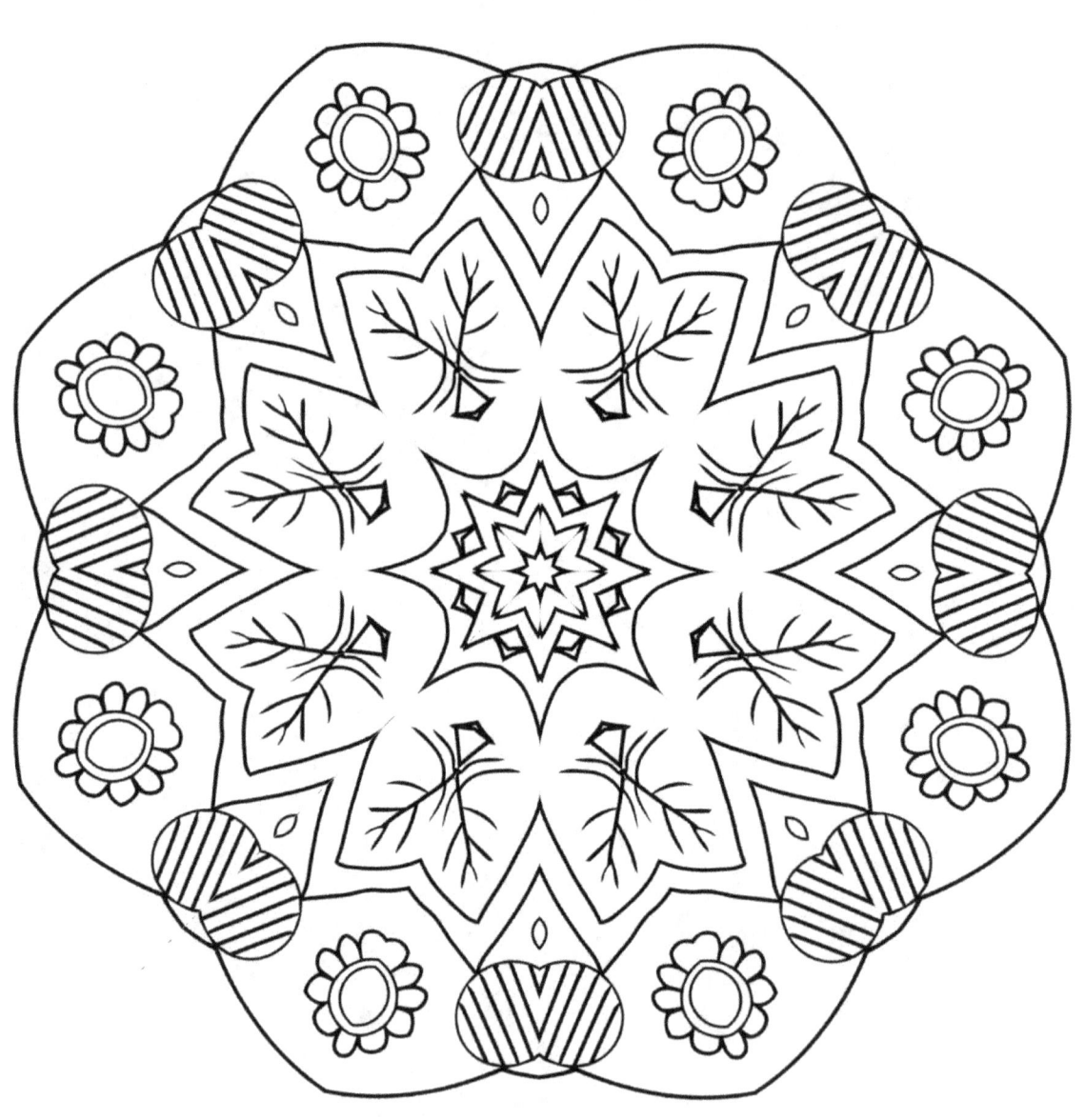

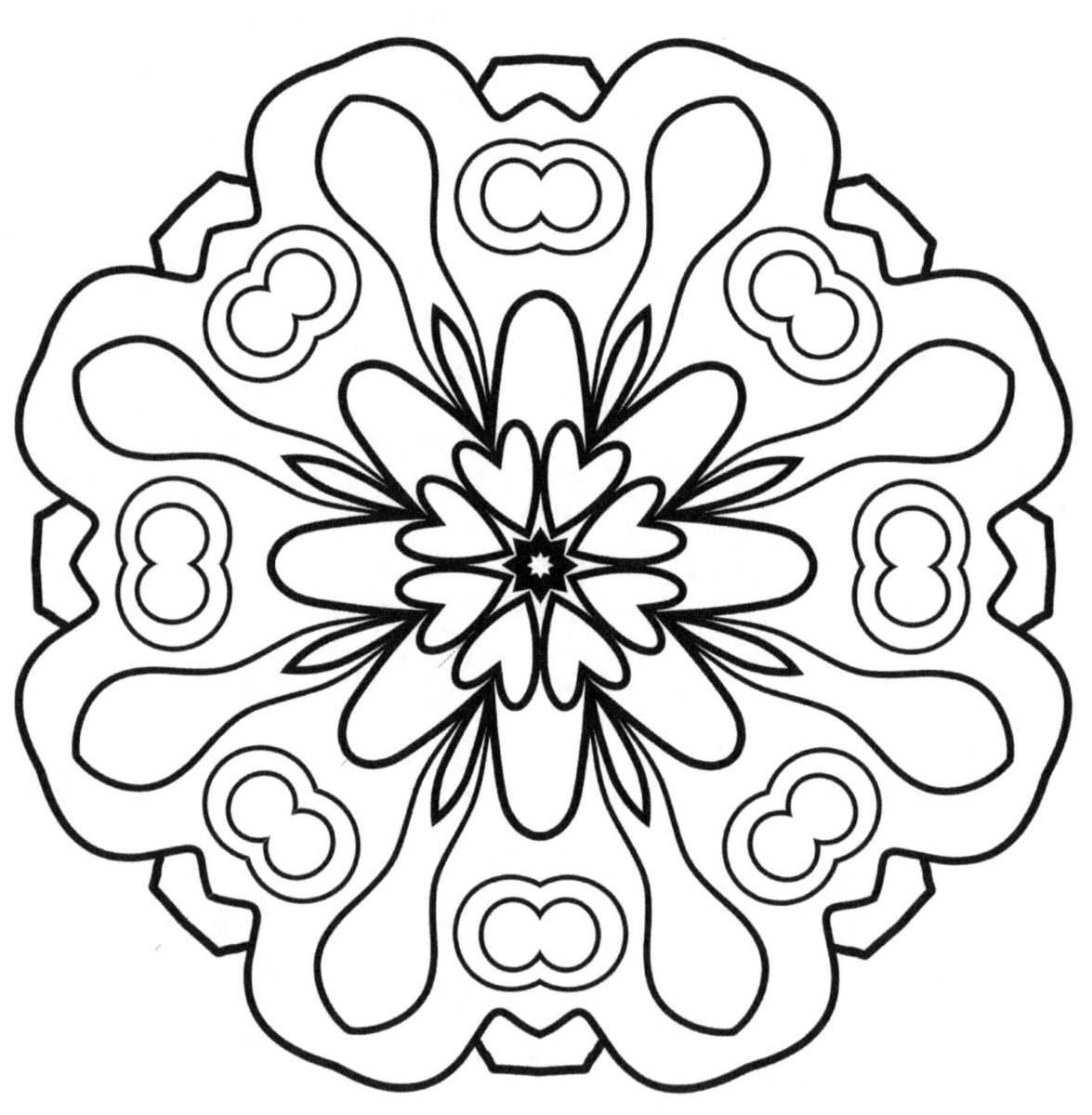

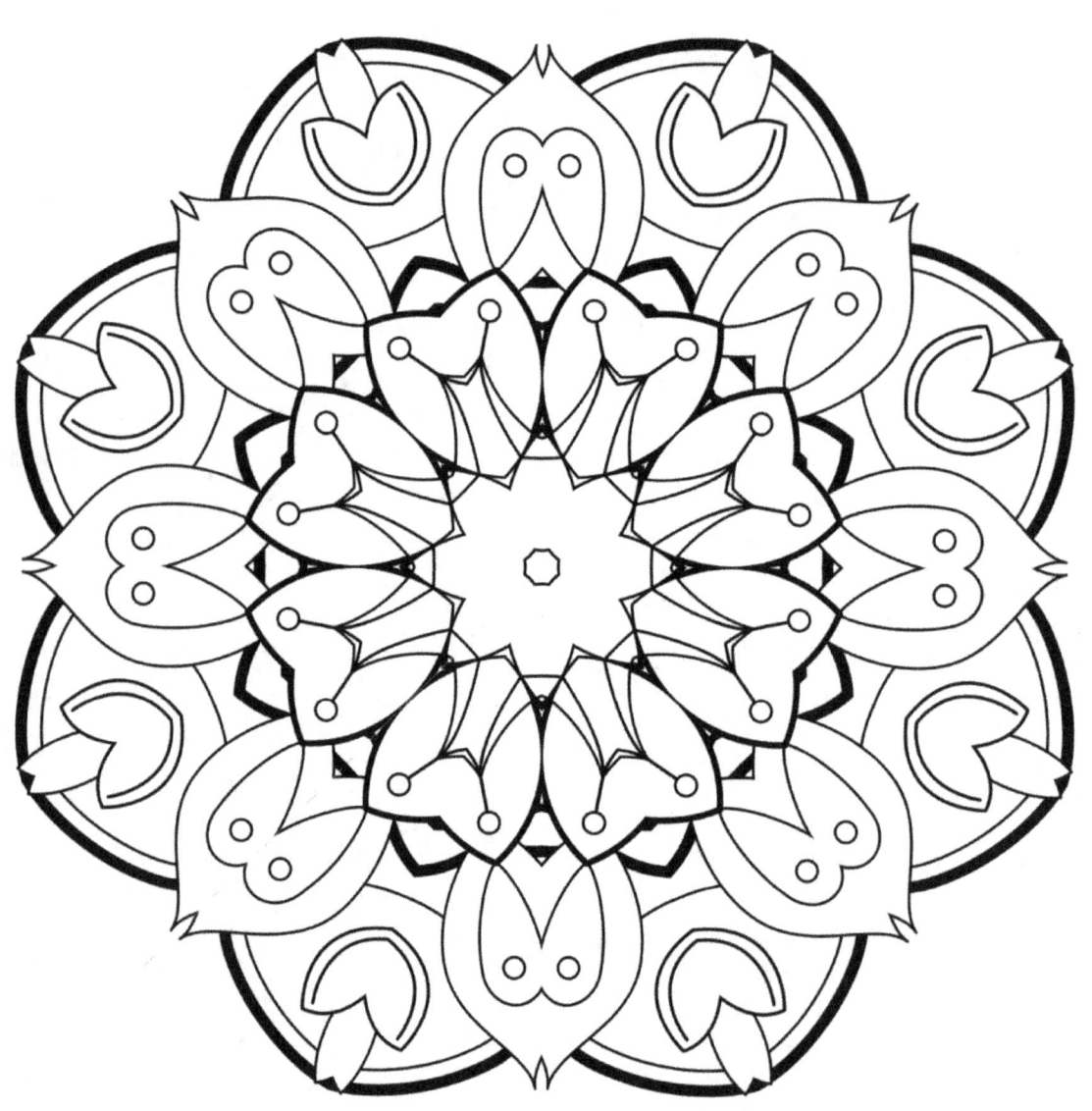

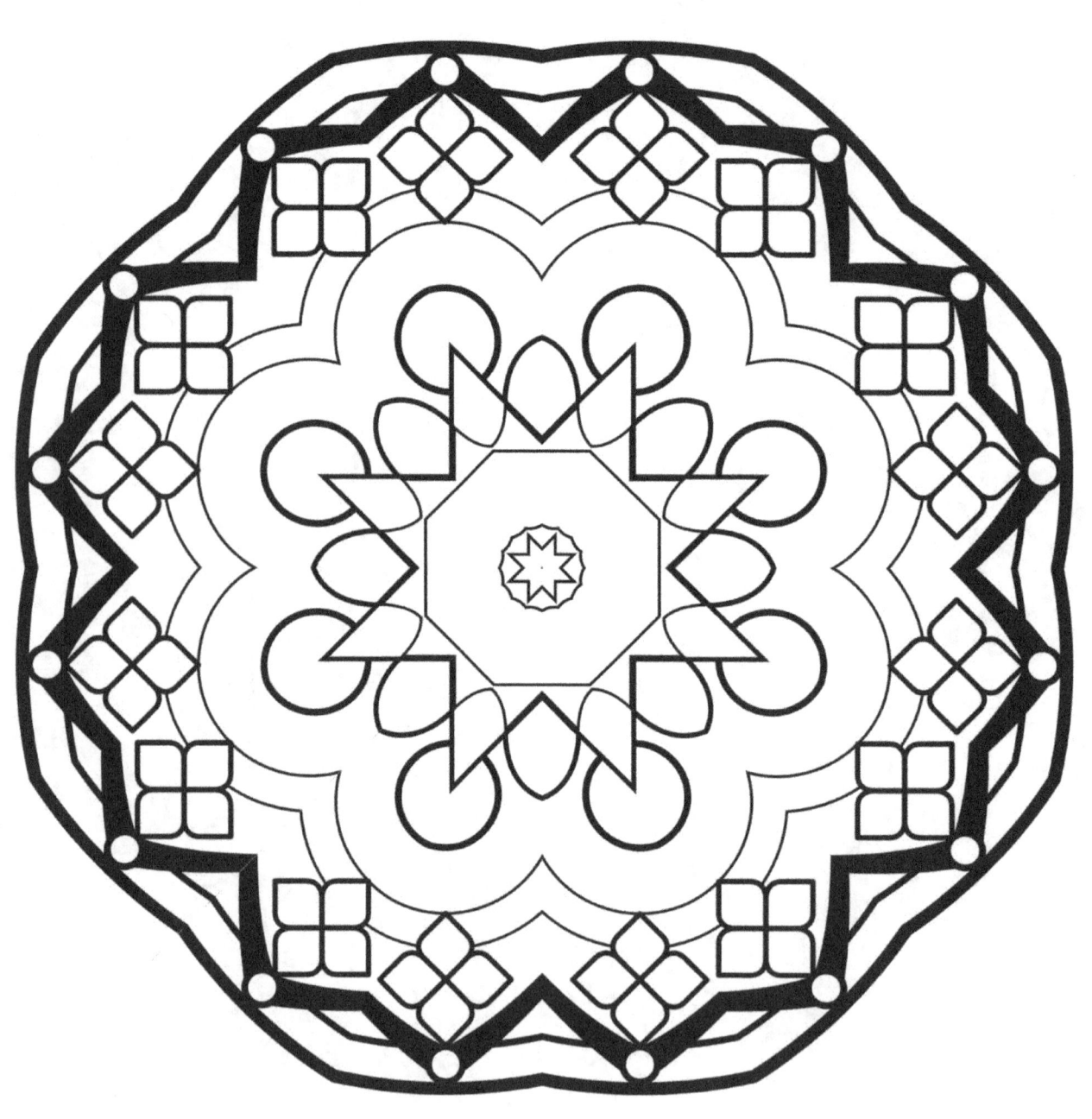

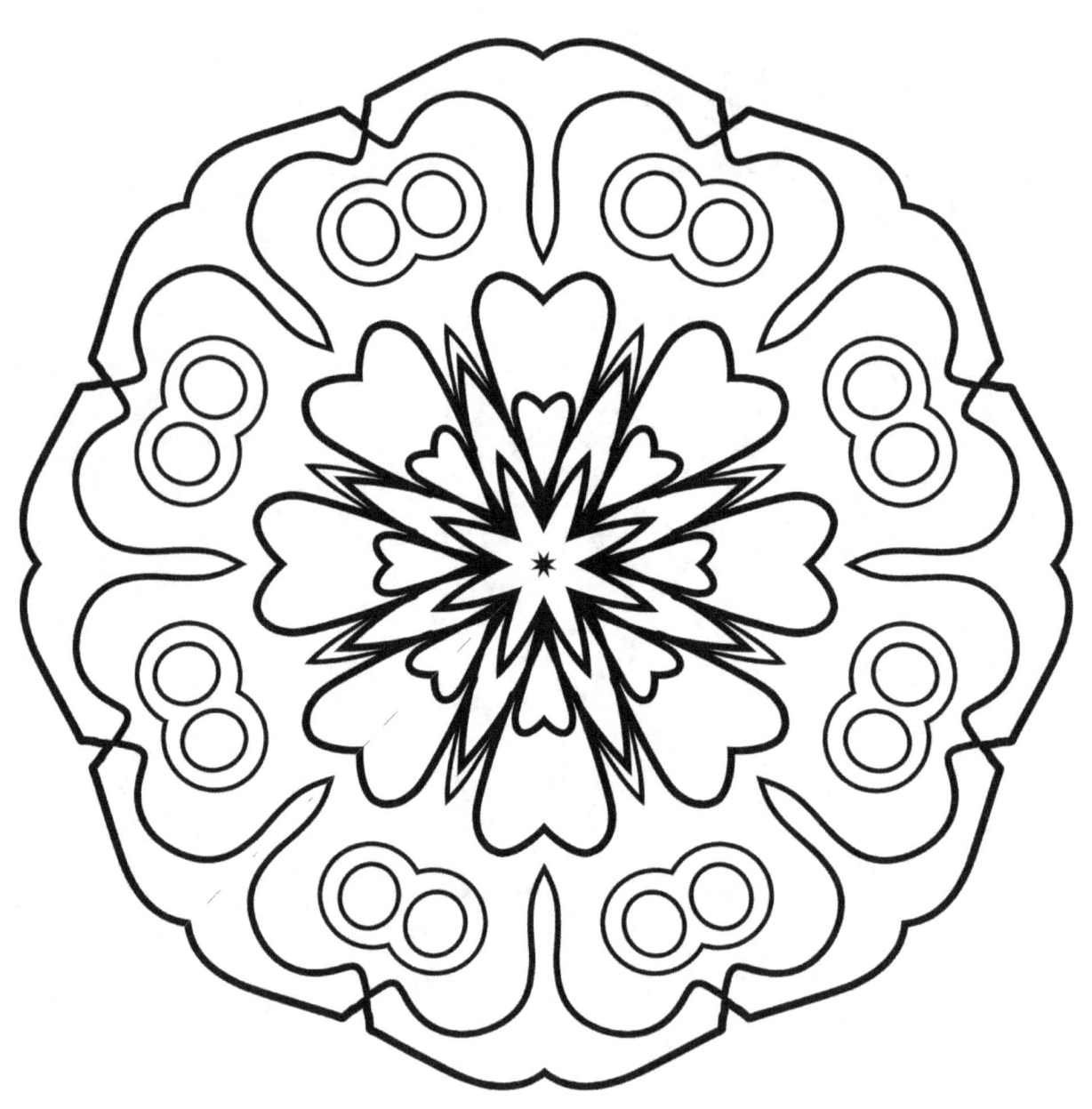

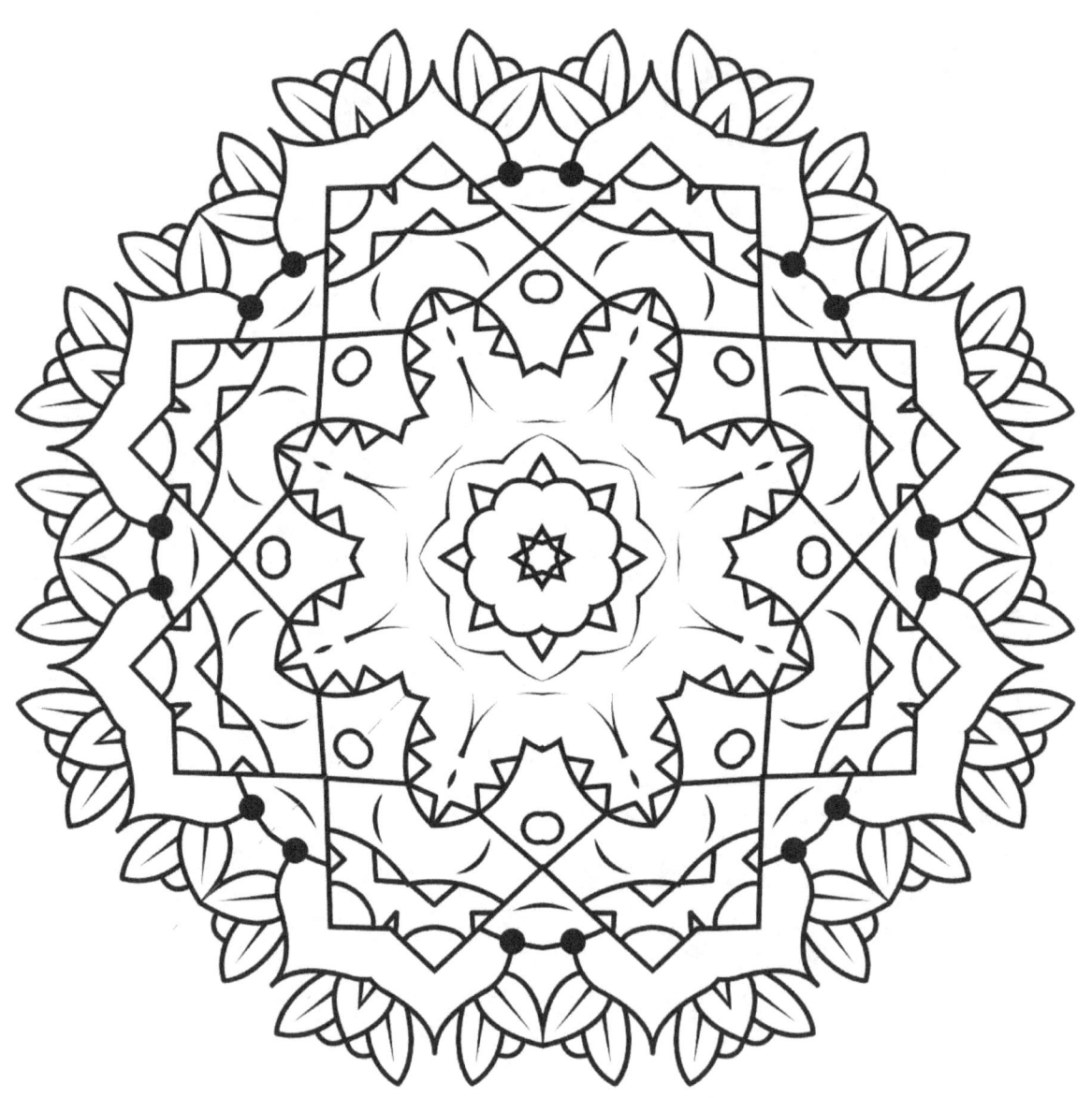

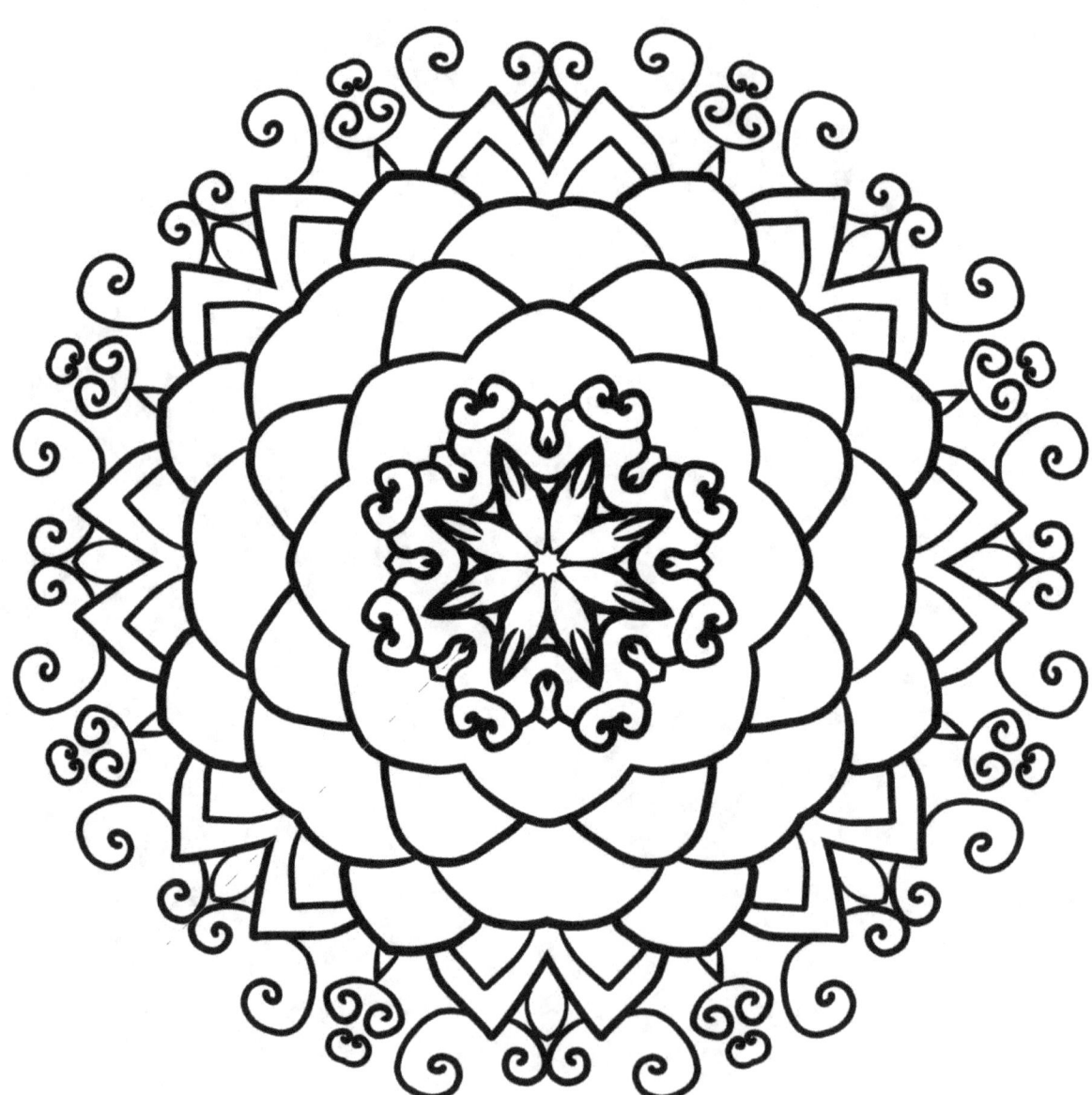

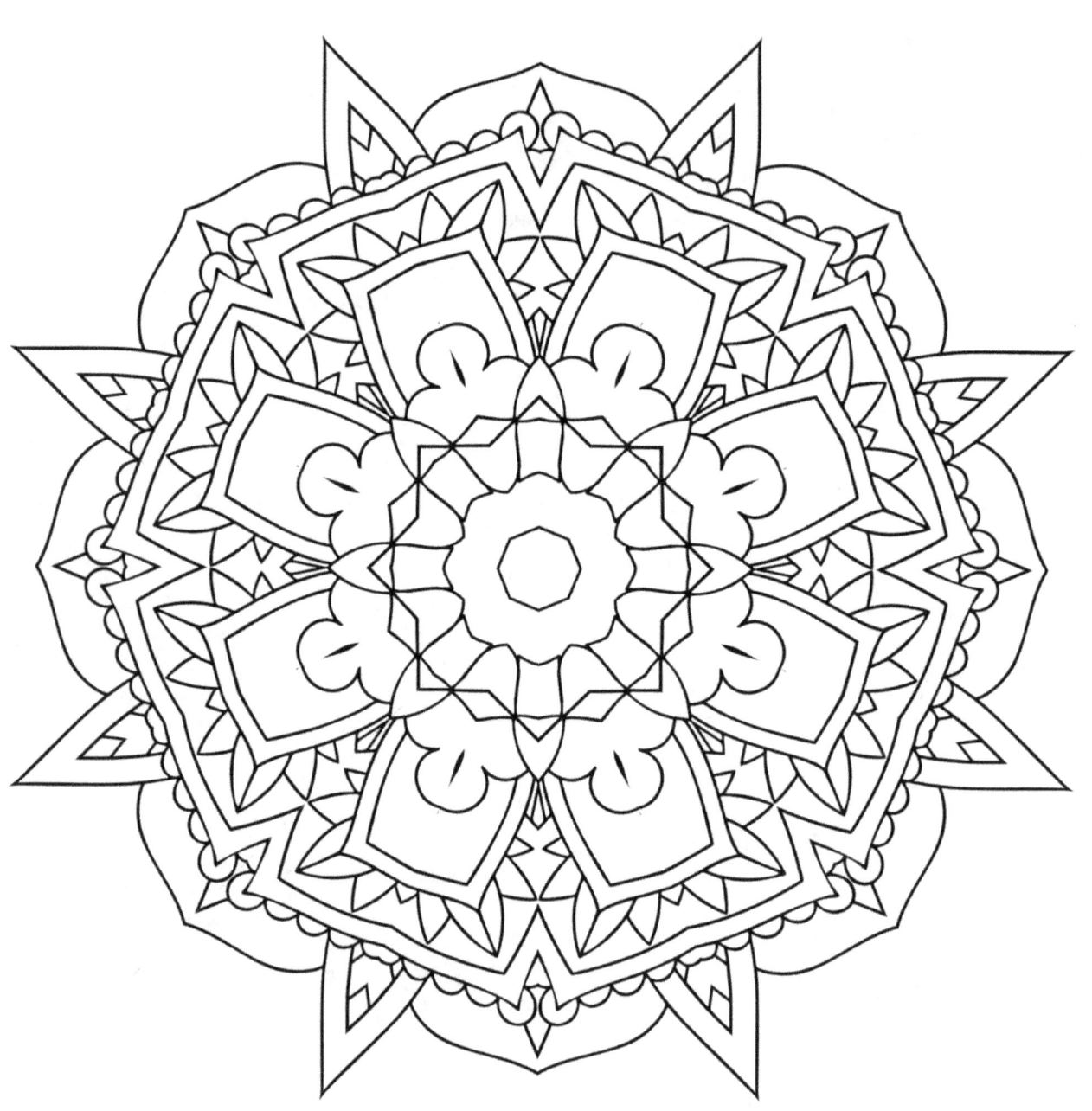

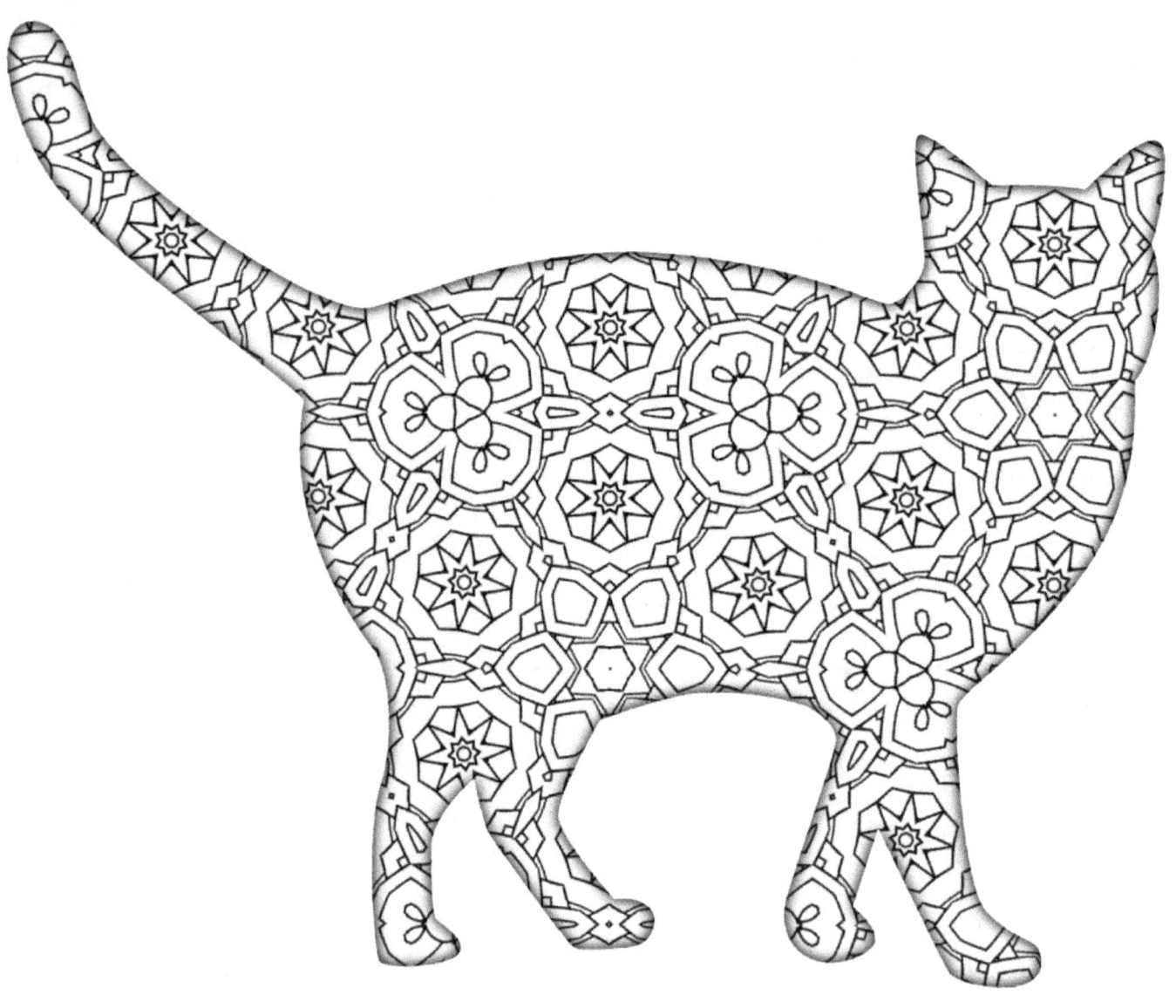

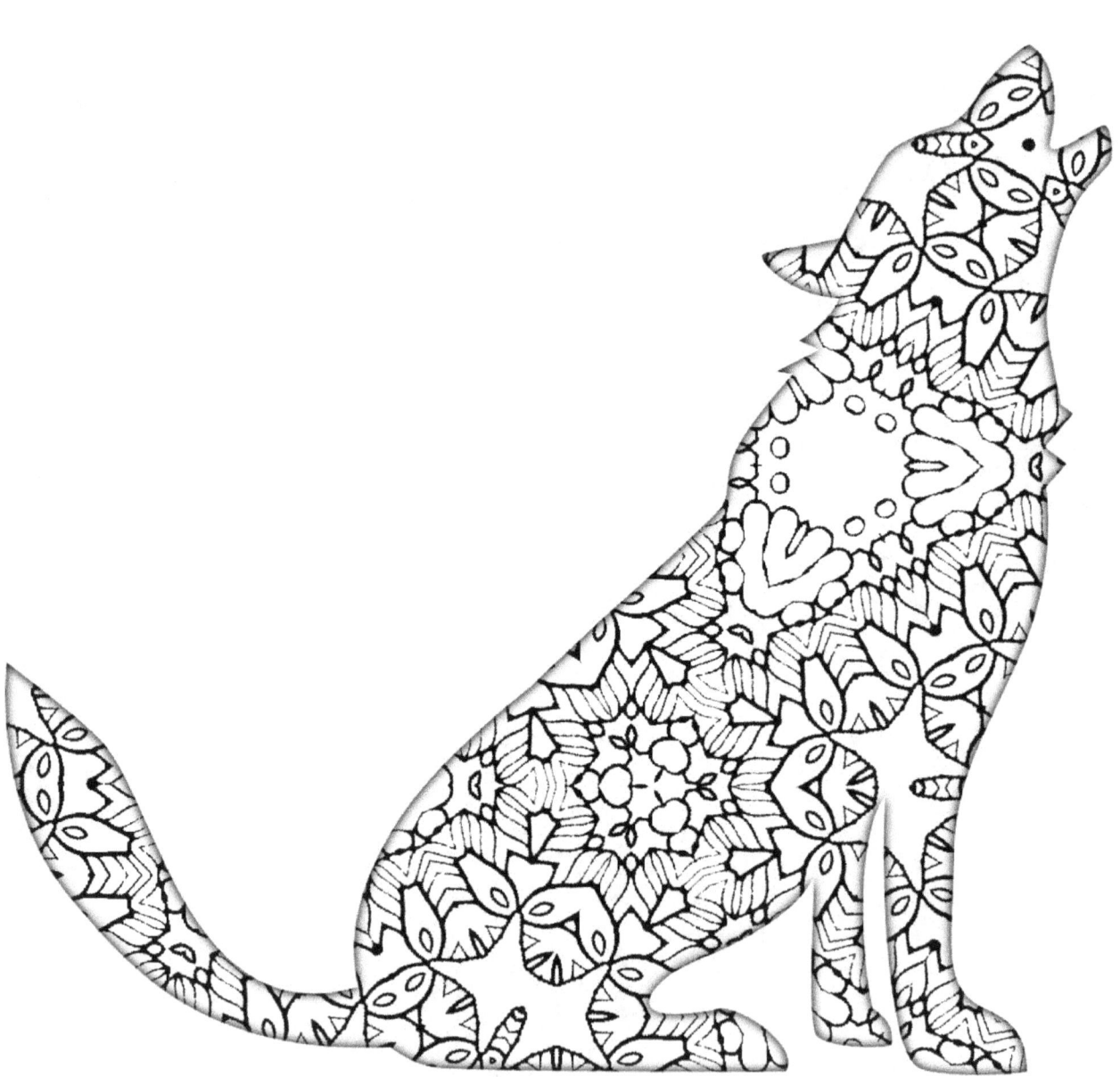

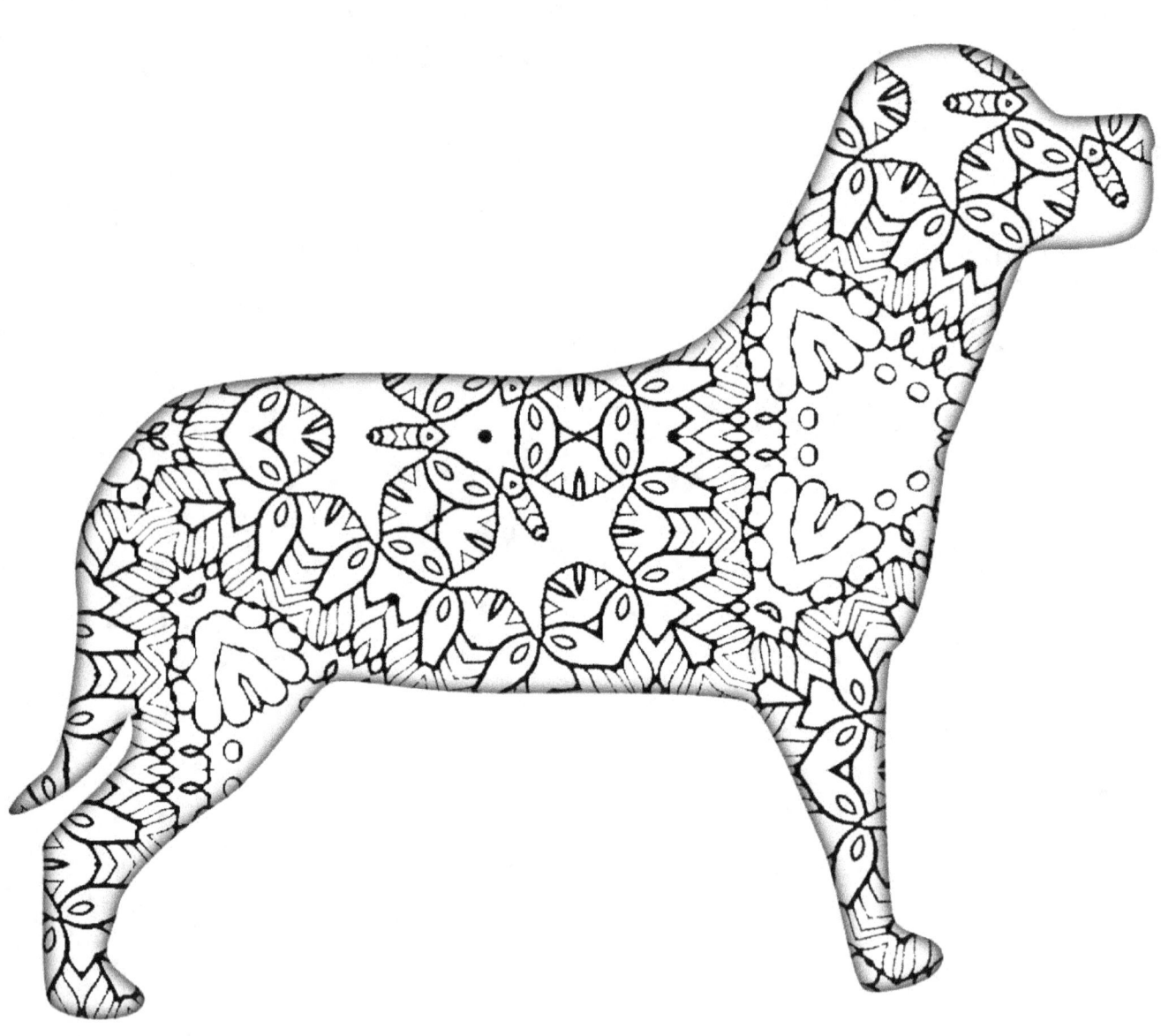

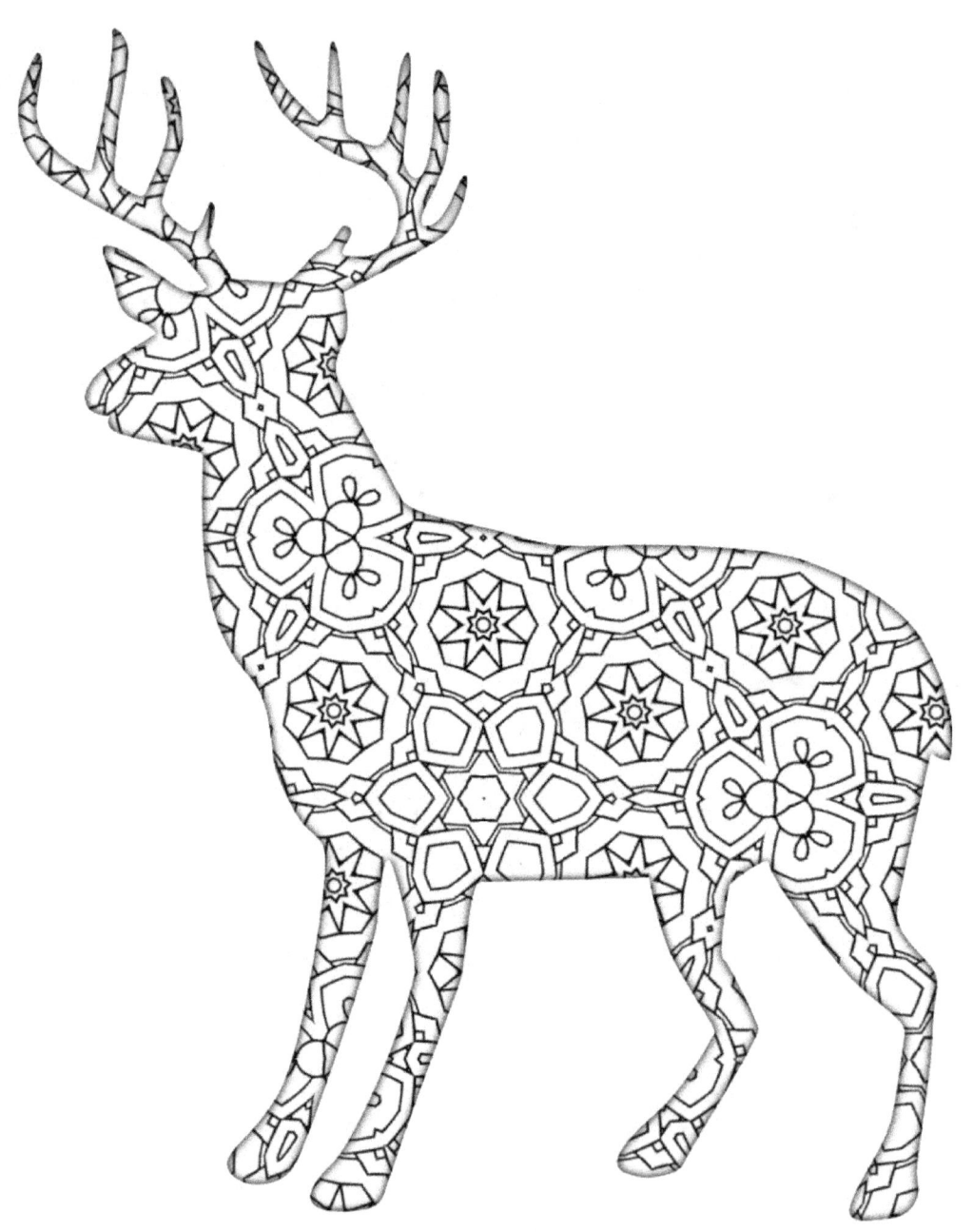

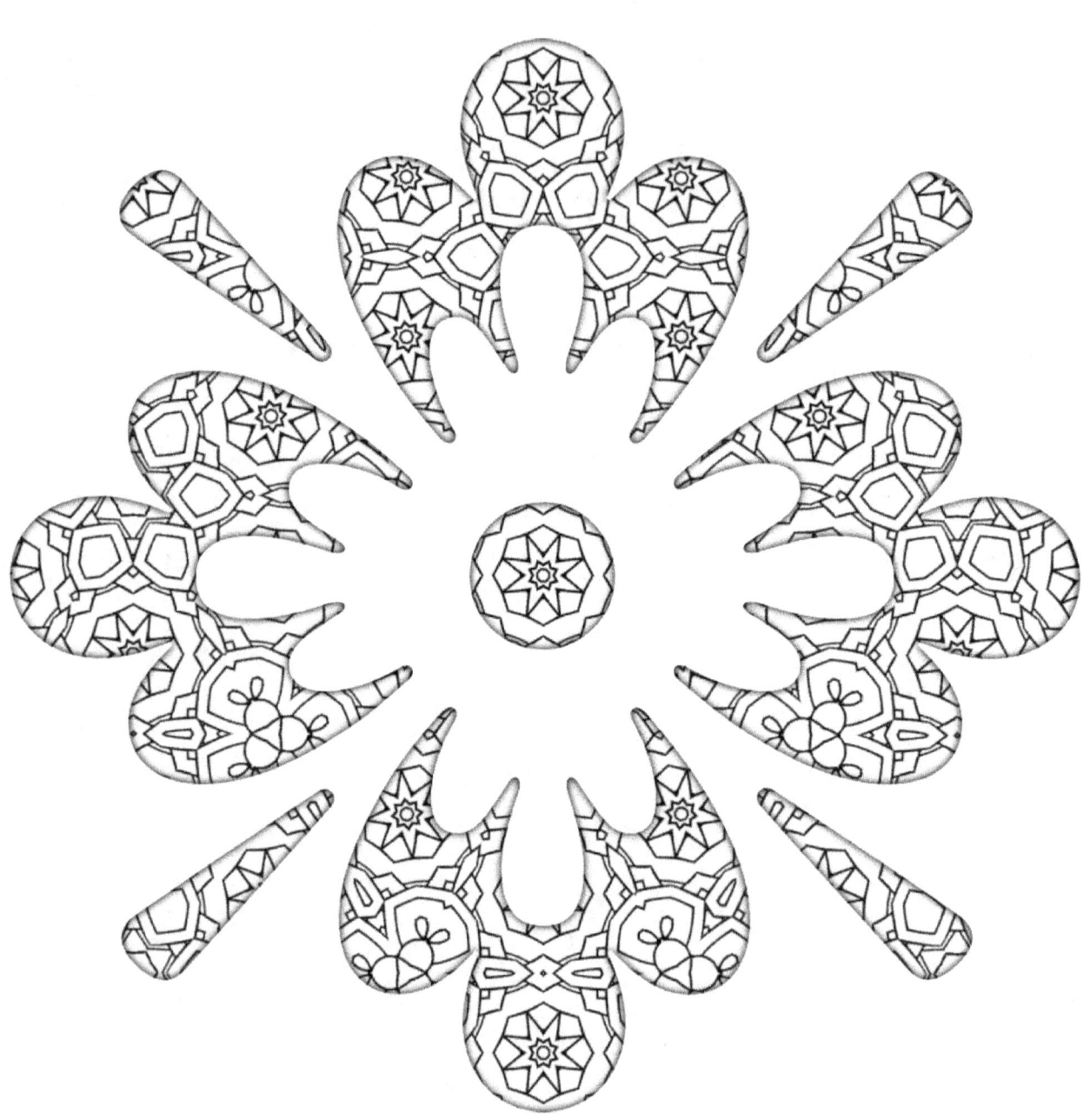

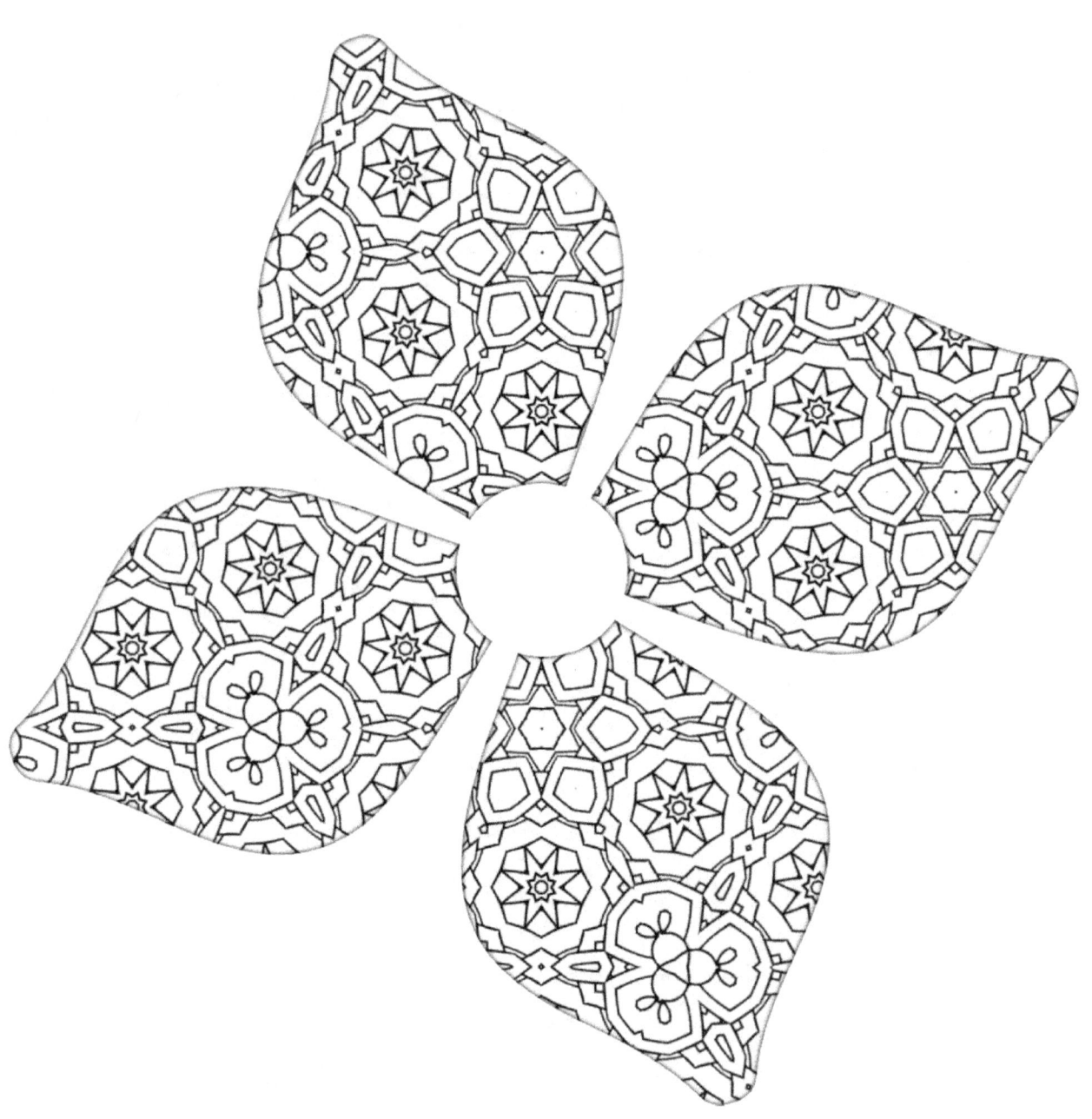

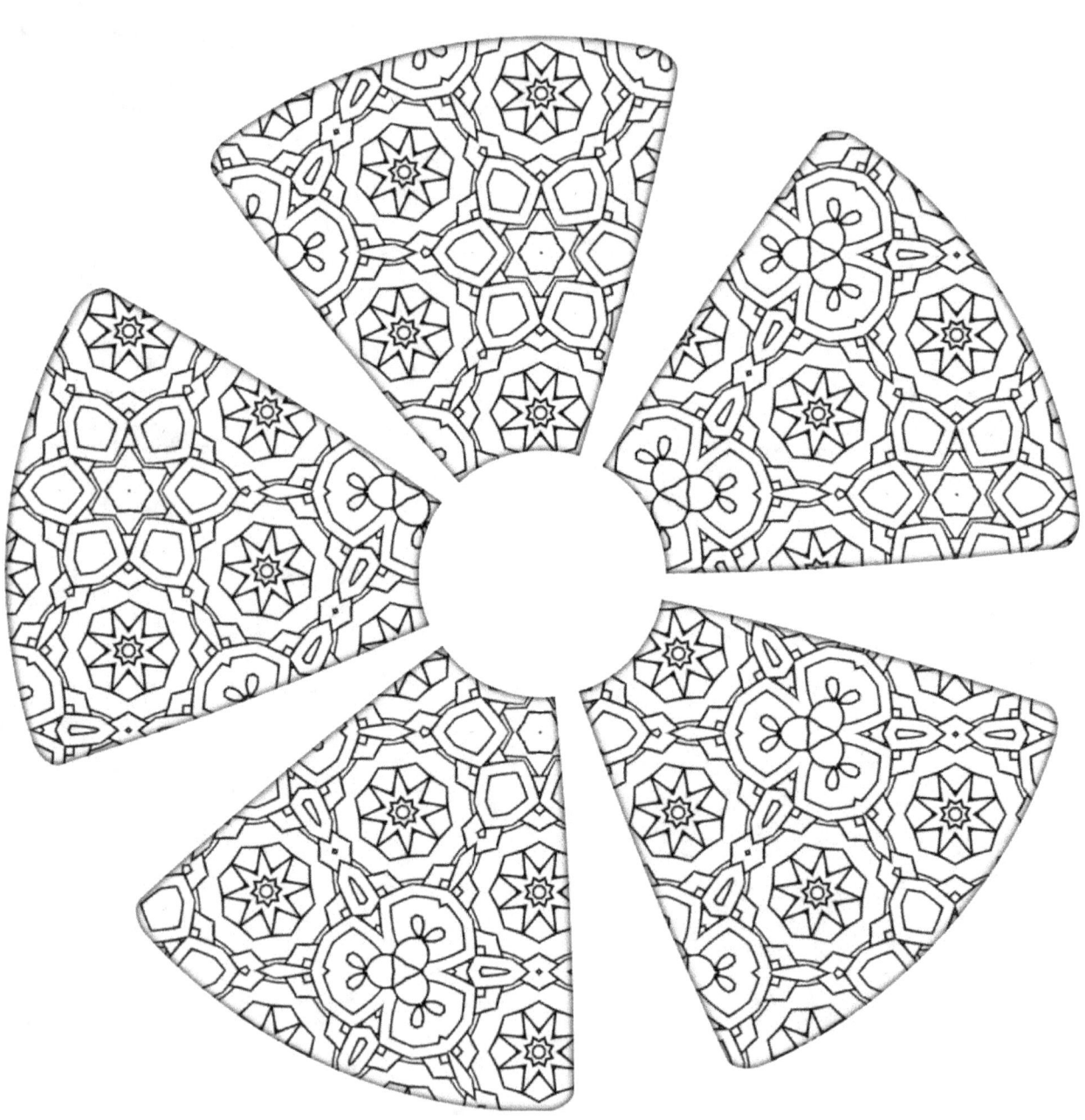

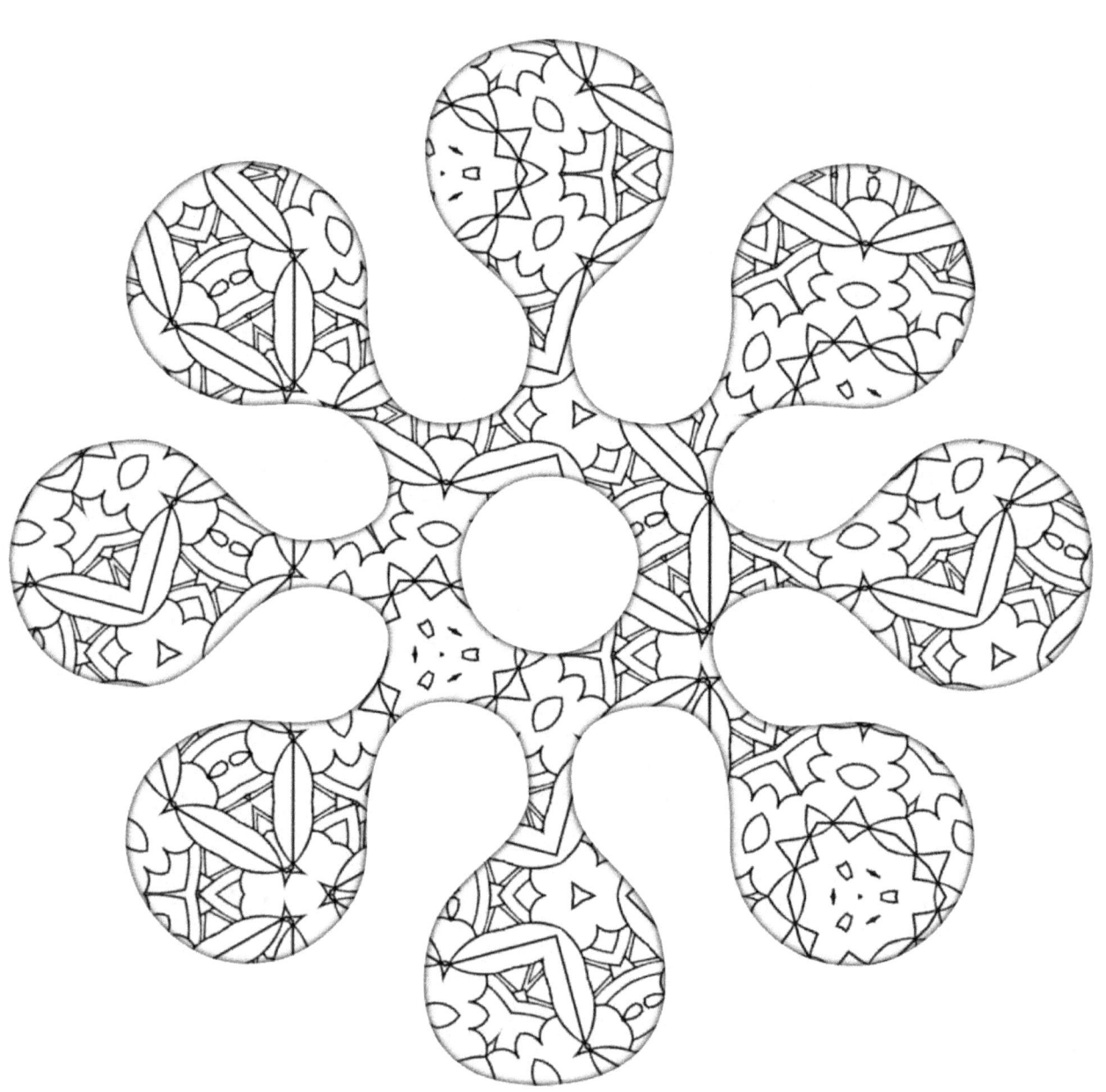

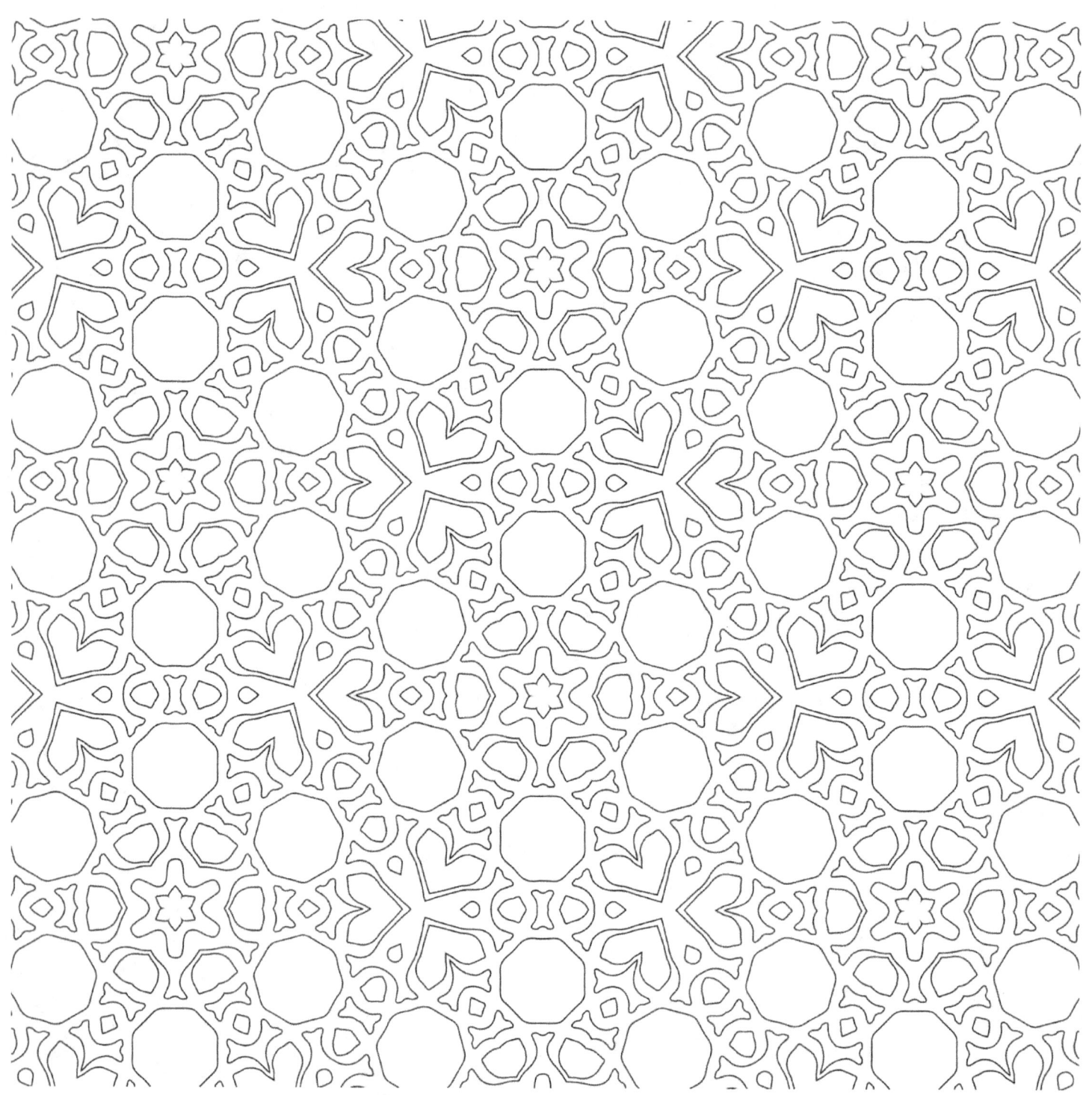

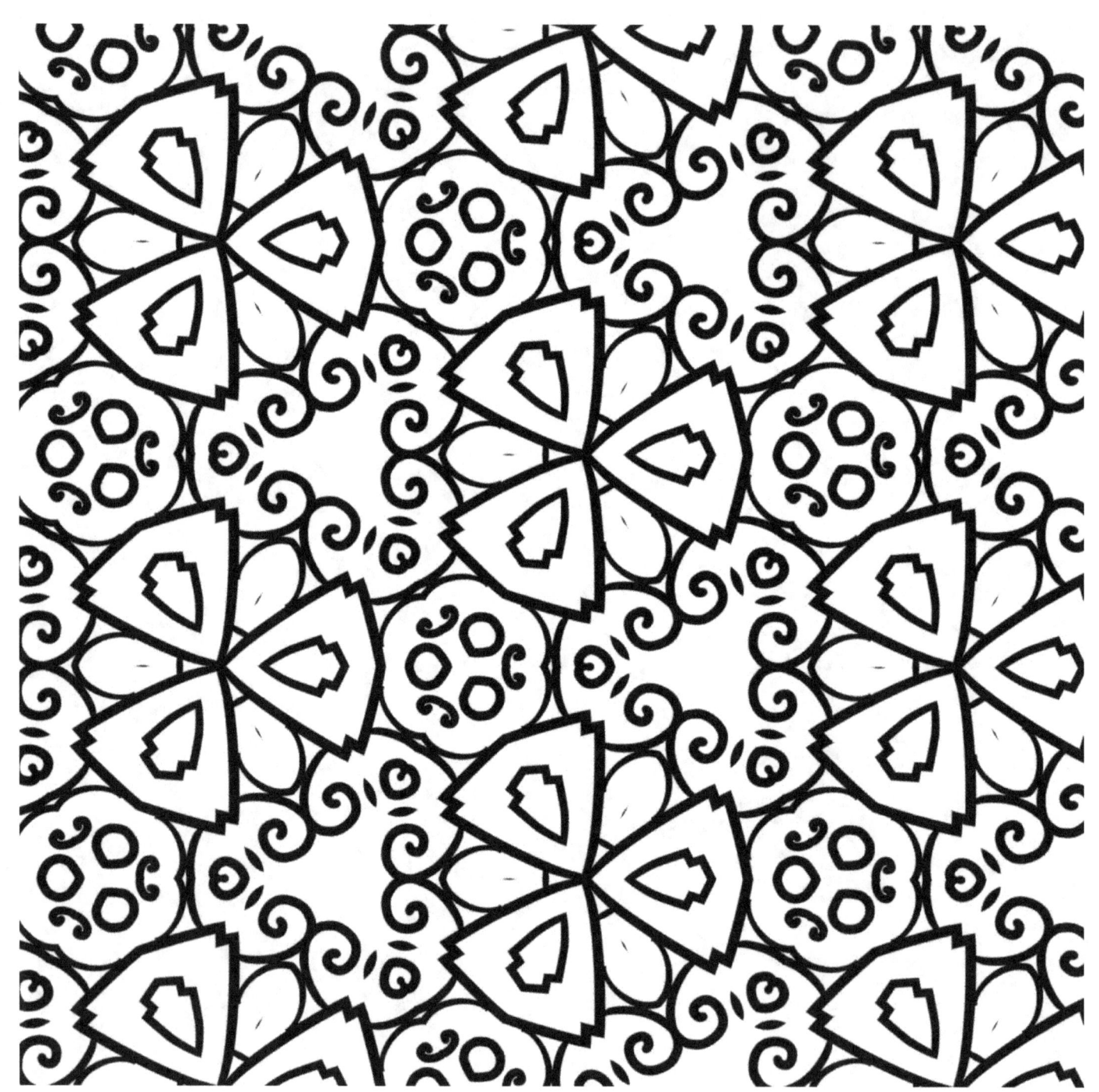